Date Due

	WD		

CAT. NO 24 162 PRINTED IN U.S.A.

BRO
DART Printed in U.S.A.

Colour: basic principles and new directions

The paintings of the Impressionists, constructed with pure colours, proved to the next generation that these colours, while they might be used to describe objects or the phenomena of nature, contain within them, independently of the objects that they serve to express, the power to affect the feeling of those who look at them.

Henri Matisse[1]

How important it is to know how to mix on the palette those colours which have no name and yet are the real foundation of everything.

Vincent Van Gogh[2]

1 Henri Matisse, 'La Chapelle du Rosaire', in Eric Protter, *Painters on Painting*, New York, 1963, p. 182.

2 'Vincent Van Gogh', in *From The Classicists to The Impressionists*, Elizabeth Gilmore Holt, ed., New York, 1966, p. 478.

1 *Ray Parker*. *Untitled*. 1965. 46 1/2 x 49″. Collection Ascher Opler. Photo courtesy of the artist.

Colour: basic principles new directions

Patricia Sloane

Studio Vista : London
Reinhold Book Corporation : New York
A subsidiary of Chapman-Reinhold Inc.

A Studio Vista/Reinhold Art Paperback
Edited by John Lewis
All rights reserved
Published in London by Studio Vista Ltd
Blue Star House, Highgate Hill, London N19
and in New York by Reinhold Book Corporation
a subsidiary of Chapman-Reinhold Inc.
430 Park Avenue, New York, NY 10022
Library of Congress Catalog Card Number 68-29048
Distributed in Canada by General Publishing Co. Ltd
30 Lesmill Road, Don Mills, Ontario
Set in 9/12 Grotesque (Monotype Series 215)
Printed in the Netherlands
by Drukkerij Reklame NV, Rotterdam
British SBN 289 36957 6 (paperback)
 289 37051 5 (cased)

Contents

Diagrams by Patricia Sloane and Frank Pastore

1. Contemporary society and a new view of colour

Pink vinyl shoes ... dresses in fluorescent colours ... fuchsia sofas ... canary-yellow refrigerators ... chartreuse dinner dishes ... silver lamé overcoats ... green-and-orange parti-coloured suits ... crimson automobiles ... flaming orange cooking pots ... magenta shirts for men ... green neckties with huge crayon-yellow dots ... neon-coloured rain slickers and purple umbrellas ... wastebaskets painted with 'op' or 'psychedelic' patterns ... bank cheques in your choice of hue ... an extended range of colours and an extended range of materials which create new colour effects (lamé and ciré and anodized aluminium and vinyl and tinted transparent plastics) ... scarlet nylon yacht rope and yellow tarpaulins ... construction workers in orange rain-suits and surgeons in kelly-green operating-room gowns ...

... It might be supposed that, while contemporary art has ceased to imitate life, life has begun to imitate the brilliant and extravagant colours of contemporary art. A high proportion of the manufactured objects of the last twenty years—like most of the art created since the era of the French Impressionists—is remarkable for bold, experimental, and uninhibited use of colour, and remarkable also for the introduction of ranges of not previously familiar colour effects. In contemporary life and in contemporary art, the power of colour has been revealed and recognized. Man lives no longer in that veiled and basically monochromatic world which, under the euphemism of 'tastefulness', assented to the greying, subduing, and inhibiting of virtually all imaginative or individualized use of colour. Traditional 'tastefulness' restricted colour choice to a minimal range; traditional 'tastefulness' placed strong taboos on the use of certain colours, and limited the sets of colour combinations which could be created. Today, the narrow formulae of yesterday's tastefulness are being replaced by a growing commitment to visual sensibility and to the creative use of colour. Basic colour combinations such as blue/green, red/purple, green/orange, are no longer labelled 'clashing' and unsuitable. Large areas of bright red are no longer declared to be 'loud'. The use of

2. Stuart Davis. *Semé*. Oil on canvas. 52 x 40″. Davis, who redefined 'form' as 'colour-space', suggested that new colour concepts played a key role in the development of contemporary art. Photo courtesy of The Metropolitan Museum of Art, George A. Hearn Fund, 1956.

3. Six-hue colour division. The 'rainbow' or spectrum is a continuum, and there have been varying views on the number of major hues into which the spectrum should be sub-divided. Six-hue division, illustrated here, is the most common method. Each black crescent represents a 'primary' colour, each shaded crescent, a 'secondary' colour. Each secondary colour on this 'colour wheel' is composed of a mixture of the two primary colours which lie next to it; each colour lies opposite its 'complementary' colour. Although division of the spectrum into six hues is common today, Sir Isaac Newton originally suggested *seven* major hues, with the colour Indigo lying between Blue and Violet.

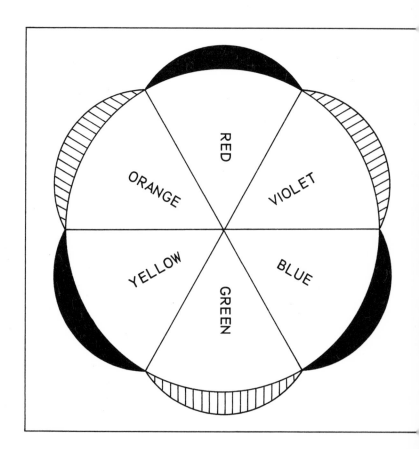

strong colours in small rooms is no longer authoritatively concluded to be 'oppressive' or excessive in effect. 'Shocking pink', which formerly must have been considered 'shocking', does not seem so today. A rich and broad range of colour effects is not only appreciated, but is actively sought. The opportunity for individualized colour-choice is considered requisite; seldom will a man purchasing an automobile be satisfied, today, if a car dealer offers him only black automobiles.

The painter Fernand Léger suggested that 'colour is a basic human need like fire and water . . . a raw material indispensable to life'. It might be added that freedom in the *use* of colour, a freedom unshackled by conventional restraints, is today considered basic. The unchaining of colour from conventional restraints has proceeded gradually but surely in both art and life, and has proceeded through interaction of diverse factors. To some extent, the development of freedom in the use of colour signifies—has paralleled—the development of a greater degree of aesthetic freedom in art, the development of a greater degree of emotional freedom in life. To some extent, colour freedom depends upon, and has been made possible by, a technology which has created new materials, new colours, better dyes and pigments. To some extent, use of vivid colour in today's manufactured objects is a direct reaction against the extreme colour restraints of the 1940's, a decade notable for the dictatorial mandates of the monochrome parlour, the white kitchen, the pastel nursery, white shirts for men, tan raincoats, black dresses on Sundays for women . . . and white dresses on Sunday for little girls.

Whatever the relative importance of each factor which has contributed to the genesis of today's colour sensibility, and to the discarding of yesterday's colour conventions, it seems certain that the artists and designers of tomorrow will, more than their predecessors, treat colour as a factor of major—not minor—creative importance. In future, more designers (and more people) will have a highly developed sensibility

4. The five 'parent' colours and the secondary colours in classical Japanese painting. Instead of the Western method of deriving the spectral colours from the three 'primary' colours (red, yellow, blue), classical Japanese painting proposes five primary, or 'parent', colours; the secondary colours in Japanese art thus differ from our secondary colours, due to the differing initial subdivision. *Iro no kubari*, a cardinal principle of Japanese colour harmony, states that a primary or parent colour should never, in a painting, be placed so that it is contiguous to any of the secondary colours of which it is a component; both colours would lose by such juxtaposition. The parent colour, white, should not, for example, be placed next to sky blue, since white is one of the components of sky blue.

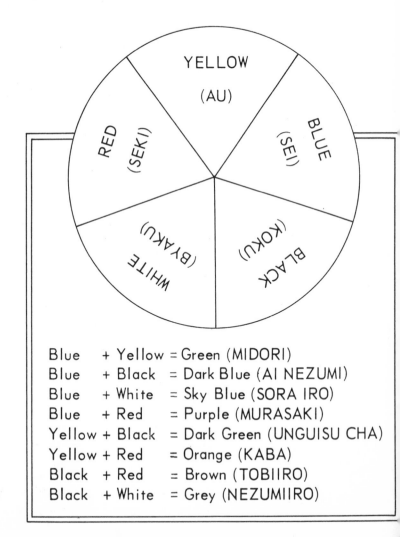

```
Blue    + Yellow = Green (MIDORI)
Blue    + Black  = Dark Blue (AI NEZUMI)
Blue    + White  = Sky Blue (SORA IRO)
Blue    + Red    = Purple (MURASAKI)
Yellow  + Black  = Dark Green (UNGUISU CHA)
Yellow  + Red    = Orange (KABA)
Black   + Red    = Brown (TOBIIRO)
Black   + White  = Grey (NEZUMIIRO)
```

5. Kenneth Campbell. *The Innocent; Crucifix* (detail). h. 72″. 1962-65. Belgian and Carrara marbles. Colour may be *in* objects, rather than *on* them. The white stripe in this carving was created by lamination of black and white marbles. Epoxy was used for the lamination. Photo courtesy of the artist and Egan Gallery.

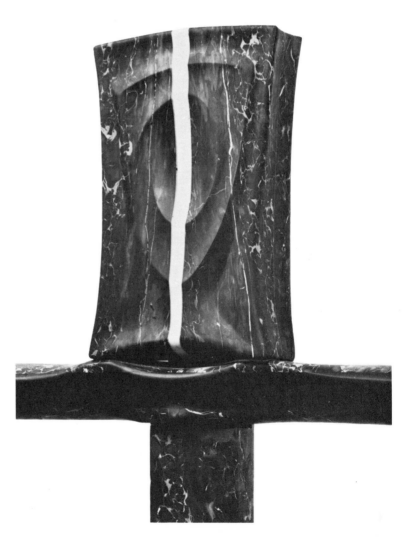

to colour, and will make efforts to train themselves to that sensibilit
Stereotype response to colour, passivity to the visual or empiric dat
of colour, will not return. But if the confused, conglomerate, inchoat
and internally self-contradictory body of data at the moment referre
to as 'colour theory' is ever to be metamorphosed into a coheren
rationally defensible 'science' of colour, this will, of necessity, occur i
the future—perhaps the far future—for conditions requisite to suc
a development have not existed in the past.

Today's new colour freedom is also a new receptivity to the object
ive aspects of colour, and such receptivity is requisite to the eventua
development of coherent colour conceptualization. The severing o
colour from the stereotype data of colour symbolism, the separatio
of colour from the moralistic imputations of 'tastefulness', the passin
of socially determined colour restrictions, colour conventions, and stan
dardized ways of thinking about colour, have today for the first tim
opened the way to the eventual possibility of a visually oriented, empiri
cally cohesive, and objective view of colour.

2. Colour science and the artist: the eye, the lens, the prism

The history of the investigation of colour vision is remarkable for its acrimony.

R. L. Gregory[3]

Crude lenses were made in ancient times; spectacles were known as early as 1260 and were discussed by Leonardo da Vinci. In *Magia Naturalis* (1589), G. Battista della Porta described the process of lens making in his day; this process changed scarcely at all until well into the twentieth century. Today, small microscope lenses may be only 1/16in. in diameter; the large telescope lens at Yerkes Observatory, Williams Bay, Wisconsin, is forty inches across. The largest telescopes replace the transparent lens with a concave mirror. The Fresnel lens, used for lighthouse lamps, was originally conceived by le Comte de Buffon in 1748, and replaces the continuous lens surface by a series of concentric rings.

Lenses (and also prisms) operate through refraction, or the bending of light as it passes from one medium into another. The law governing the degree to which refraction will occur, formulated by Willebrord Snell in 1621, was published by René Descartes after Snell's death.

'Prism,' in optics, refers solely to triangular glass prisms of the type used by Sir Isaac Newton; in solid geometry, however, 'prism' is a term referring to a specific class of polyhedronal shapes. In 1666, Newton, then 23 years old, began a long series of optical experiments. In his most famous experiment, a glass prism was placed in a single ray of sunlight which entered a darkened room. Passing through the prism, the ray was refracted, and emerged as the familiar solar spectrum, or 'rainbow', which Newton designated as red, orange, yellow, green, blue, indigo, and violet. It had been known previously that a prism would split light in this manner, but previous hypotheses had suggested that the glass of the prism was permanently and irreversibly changing the substance of the light. Newton, with a second prism, demonstrated that the spectral colours could be re-combined into white light again, and gave the first explanation of white light as a combination of the spectral colours.

3. Gregory, R. L., *Eye and Brain: The Psychology of Seeing*, N.Y., 1966

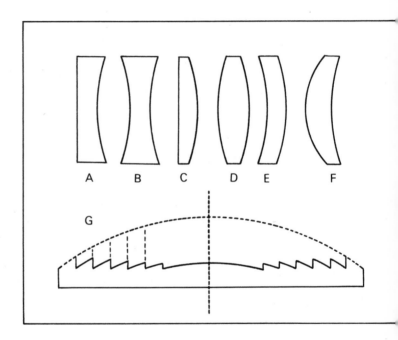

6. Cross-sections of lenses. The word 'lens' is Latin for 'lentil', the shape of which resembles a biconvex lens. A) plano-convex, B) bi-concave, C) plano-convex, D) bi-convex, E) concavo-convex, F) meniscus, G) the Fresnel lens, in which the continuous lens surface is replaced by a series of concentric rings

One of the developments from Newton's experiment had been the modern science of spectroscopy, or spectrum analysis, involving the later discovery that each of the chemical elements creates—when heated to incandescence—its own unique spectrum, varying in the proportions of the colours. Spectra of the light emitted by distant stars can be colour analysed by use of various machines, and the chemical elements of which the star is constituted can be inferred from colour analysis of its spectra.

The eye: Leonardo Da Vinci observed that man, when threatened, moves first to protect his *eyes;* most myths and legends involving the eye stress this universal human feeling that the eye is man's most precious possession. In the Greek Oedipus myth, loss of the eyes represents the ultimate punishment; Oedipus puts out his own eyes to punish himself for his unwitting incest. Among the Indians of North America, and the Taulipang tribe of South America, folk-tale tells of the Eye-Juggler, who possessed the power to throw his eyes up into the air and then replace them again in his head. Warned to perform this trick only a specified number of times, the Eye-Juggler disobeyed, and used his power once too often. As punishment, he forfeited his eyes, but later was cleverly able to replace his lost eyes with the eyes of an animal. In contemporary Surrealist mythology, the most famous scene in *Le Chien Andalou,* a film by Salvador Dali and Luis Buñuel, shows a large eye-ball being sliced by a razor-blade.

The eye is essentially a lens system, not dissimilar in structure to a camera. Light enters the eye through the pupil and falls on the retina, the transparent lining of the eye. The retina varies from 0.2 mm to 0.3 mm in thickness, and the light receptors responsible for sight are located in a layer on its back surface. In the centre of the retina, where the optic nerve makes contact, a blind spot exists, devoid of receptors. The retina's light receptors are of two types, called cones and rods because of their shapes. In daylight, the eye adapts itself to ordinary ,or *photopic* vision, and sees

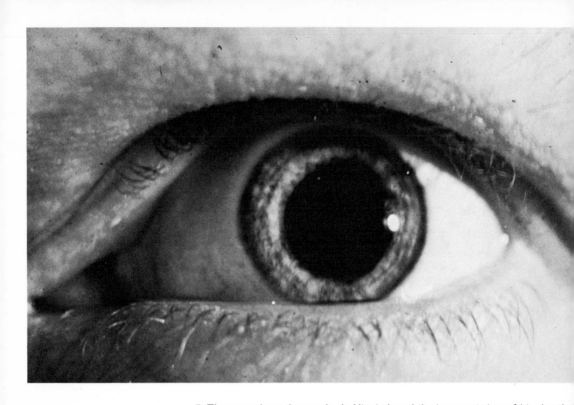

7. The normal eye. Leonardo da Vinci shared the incorrect view of his day that weeping was initiated by the feelings of the 'heart'. Hence, in his anatomical drawings of the eye, he showed the tear duct (left in the photograph) leading directly to the heart. Photo courtesy of National Medical Audio-visual Centre of the Department of Health, Education, and Welfare.

with the cones, which are sensitive to colour. A photosensitive chemical called iodopsin has been found in the cones, but neither the function of iodopsin nor the manner in which the cones work is clearly understood. In 1801, Thomas Young suggested there might be red-sensitive, blue-sensitive, and yellow-sensitive cones which enabled the three primary colours to be distinguished. His suggestion remained hypothesis, for all cones appear to be alike; three different types can be neither isolated nor distinguished.

1

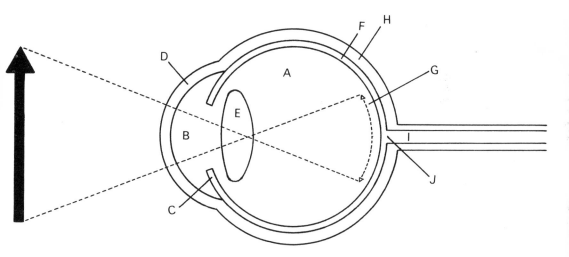

8. The human eye: cross-section. A) vitreous humour, B) aqueous humour, C) iris diaphragm, D) cornea, E) lens, F) retina, G) image formed on retina, H) sclera, I) optic nerve, J) blind spot where optic nerve joins retina.

Rods, although more light-sensitive than cones, lack the ability to convey colour sensation. At night, or in very dim light, the eye sees primarily with the rods, a phenomenon called night vision (or *scotopic* vision), in which there is little ability to distinguish colours. Rods contain a purple pigment called rhodopsin, or 'visual purple', which has been isolated from the eyes of frogs and studied. While light causes rhodopsin to change into a yellow pigment called retinene, or 'visual yellow', it is not known how or why this process affects the optic nerve.

In the retina, cones are densely concentrated in the centre, near the optic nerve; rods are concentrated at the edges. Hence in darkness, using rod vision, the central portion of the eye sees very little (a phenomenon termed 'averted vision'), and a dim object such as a faint star can be seen more clearly if the eye focuses on a spot about 20° to one side of the star rather than directly upon the star.

Both cones and rods are extremely small, the average retina containing about 6 1/2 million cones, 100 million rods. Approximately one million nerve fibres lead from the retina to the optic nerve; many cones and rods are attached to each fibre.

The structure of the eye has been studied for centuries, and Leonardo Da Vinci described in detail the manner in which the pupil (or light-admitting aperture of the eye) expands and contracts in accordance with the amount of light present. But much still remains to be known about the working of the eye, and today new facts are sometimes discovered with the aid of new machines. Recently, using a machine called a Pupillo-graph, Dr Eckhardt H. Hess of the University of Chicago has made a discovery that would seem to indicate the eye is directly affected by thoughts, feelings, and emotions. Dr Hess found that when an individual sees something which he *likes*, the pupil of his eye opens wider to admit more light. Conversely, when the individual sees a sight he regards as unpleasant, the pupil of the eye contracts, admitting less light.

9. The Bausch & Lomb binocular infra-red pupillograph, a machine used in basic research on the mechanism of the pupil of the eye. Photo courtesy of Bausch & Lomb, Inc.

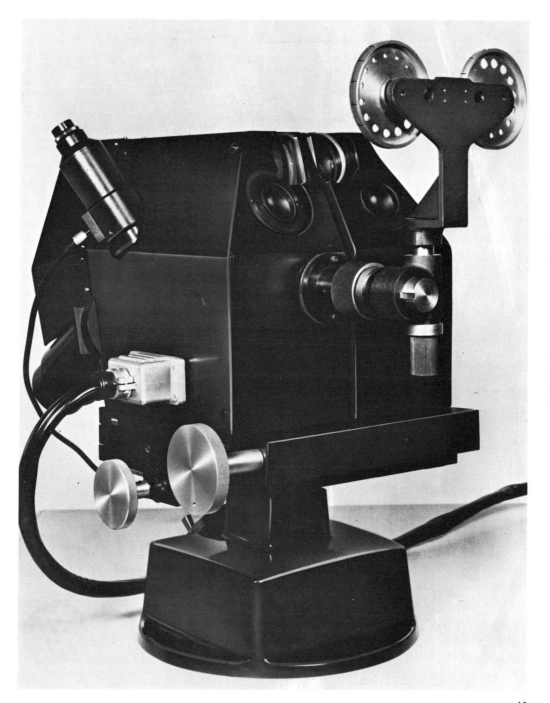

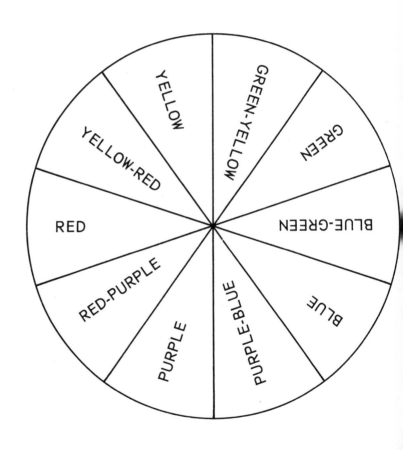

10. Ten hue colour division, used in the Munsell system. Opinion has differed o
the number of major hues into which the 'colour wheel' should be subdivide
Ten, twelve, and sixteen have been among the numbers suggested.

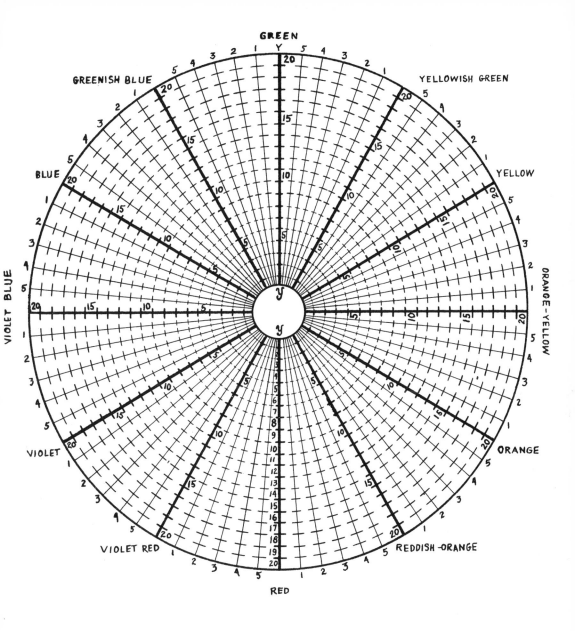

11. Chromatic diagram (after Chevreul). M. E. Chevreul's diagram of the relationships between the spectral hues differs from that of Munsell in containing twelve, not ten, major hues.

3. Colour notation: premises and format of the Munsell and Ostwald systems

Painters may twist the original characteristics of colours. L. Moholy-Nagy

The problem of categorizing colour, and the related problem of evolving a system of colour notation, has called forth the efforts of many artists and scientists, particularly since the eighteenth century. Graphic diagrams and, later, three-dimensional constructions were developed in the hope they would coherently symbolize the relationships of colours to each other.

The German astronomer Johann Tobias Mayer (1723-1762) devised a three-colour triangle. J. H. Lambert (1728-1777), a physicist and mathematician, invented a colour pyramid. Philip O. Runge (1777-1810), a painter of the German Romantic school, developed a colour sphere with white at the north pole, black at the south, pure hue at the equator. M. E Chevreul (1786-1889), a French organic chemist and director of the dye works at the Gobelin tapestry factory, arranged the colours in a hemisphere. Chevreul's *The Laws of Contrast of Colour and Their Application to the Arts* was read by Pissarro and several other French Impressionist and Neo-Impressionist painters. During the early twentieth century, Chevreul's theories influenced the painter Delaunay in the development of Orphism.

But by far the most well-known systems of colour categorization are those of Wilhelm Ostwald and Albert Munsell. Ostwald was born in Riga, Latvia, of German parents, on 2 September 1853. He died in Grossbothen, Saxony, on 4 April 1932. A physical chemist who taught at the University of Leipzig and at Harvard, he was awarded the Nobel Prize in 1909. At the age of 56, he retired from teaching to devote himself to philosophy and the study of colour. Prior to Ostwald's researches, colour had been evaluated in terms of 1) purity, and 2) luminosity. Ostwald substituted the three factors of hue-content, white-content, and black-content. His first *Colour Atlas*, published in 1916-17, contained 2500 colours, later abridged to 680. Particularly in Germany, Switzerland, and

4 L. Moholy-Nagy, *Vision in Motion*, Chicago, 1947, p. 156

the British Empire, his colour standards were widely used in industry.

Munsell, founder of the Munsell Color Company of Baltimore, Maryland, was born in Boston in 1858 and studied painting at both the Massachusetts Normal Art School and the Beaux Arts. His system of colour categorization is based on the factors of hue, chroma, and value. In 1905 he published the first edition of *A Colour Notation*, enthusiastically claiming, 'COLOR ANARCHY IS REPLACED BY SYSTEMATIC COLOR DESCRIPTION'. In 1915, various Munsell Color Charts were collated in *The Atlas of the Munsell Color System*. Munsell died in 1918, and in 1929 his colour charts were revised and re-issued as the Munsell *Book of Color*.

Both Munsell and Ostwald systems are essentially based on the swatch principle; use of either system centres on the utilization of a large book containing hundreds of small colour samples, each sample having its own code symbol or notation. This notation has, of course, no meaning unless the colour sample to which it refers is available. A further limitation lies in the fact that the small rectangles of matt surface paper used for the samples of the Munsell book represent only one type of surface texture. Nevertheless, since two individuals possessing Munsell books can communicate with each other verbally in regard to the colours in the book, the system has found favour in industry, especially for control of product colours. In 1943, a committee of the Optical Society of America criticized the spacing of the Munsell colours, and recommended a re-spacing.

The most serious shortcoming of both Munsell and Ostwald systems lies in the fact that while their ostensible goal is the development of a logical method of colour notation, neither theorist confines himself to his purported problem. Going beyond the analysis of what colour *is*, both become deeply involved in questions of how colour *should be used*. Here both writers, like Chevreul before them, founder in what today are revealed as

12. David Weinrib. *Statium*. 1966. 36 x 36 x 18″. Collection Whitney Museum of American Art, New York, Gift of the Howard and Jean Lipman Foundation, Inc. Most often, colour used in art is opaque colour. But colour may also be transparent (as shown here), translucent (carved alabaster, for example), or opalescent (as in Art Nouveau glass). Photo courtesy of Whitney Museum of American Art.

nineteenth-century absolutism, bland Victorian generalities, and totally obsolete rules. Munsell, concerned with nineteenth-century ideals of 'harmony', writes, 'Beauty of color lies in *tempered* relations'. Yet the purpose of colour in art is neither to be tempered nor to be harmonious, nor even to be beautiful, but, rather, to serve the ends of aesthetic communication. Munsell's suggestion that his theory of colour notation was analogous to the theory of musical notation was criticized by Rudolph Arnheim, who remarked, 'musical theory is not concerned with what sounds nicely together, but with the problem of how to give adequate shape to an intended content'.

4. Colour/Light: past and present

The study of colour has been in the past, and still is, an amorphous discipline which spans the fields of art, philosophy, language, physics (and metaphysics), physiology, psychology, and sociology. The philosopher Schopenhauer first described colour as a sensation and, to the physicist, colour is merely a sensation caused in the eye as the result of light. Hence, discussion of the nature of colour must invariably concern itself with the nature of light. Yet it is also pertinent, for the artist, to remember Cézanne's remark that 'light does not exist for the painter'.

Early in the seventeenth century, Galileo made what is probably the earliest attempt to measure the speed of light; during the latter part of the century, two important and diametrically opposed theories arose, both purporting to explain the nature of light. Either theory explained some, but not all, of the natural phenomena which had been observed:

The wave theory suggested that light consisted of waves, analogous to those created in water when a stone is thrown into it. Yet waves require a medium through which to travel. It was apparent that air could not be the vital medium through which light waves travel, for light can also travel through a vacuum. Hence it was postulated that some sort of weightless, colourless substance must permeate the entire universe, acting as a vital medium for light waves. This hypothetical medium, designated the 'ether', proved the main weak spot in the wave theory, for no way was ever found to isolate or examine the 'ether'.

The second of the classical theories of light, the theory of corpuscular emanation, regarded light as a stream of tiny flying particles, analogous to a stream of flying arrows, which entered the eye after being shot out by a luminous body. Opponents of the corpuscular theory claimed that if a beam of light were indeed like a stream of flying arrows, it would be impossible for two light beams to cross each other without the two streams of 'arrows' colliding.

WHITE

YELLOW RED BLUE

BLACK

13. The descent from white to black (after Kandinsky). A majority of the diagrams used to illustrate colour relationships graphically have been circular in form (or derived from the circle), and have separated black/white from the spectral hues. Kandinsky's unusual diagram, shown here, is a value-scale which incorporates both black/white and the 'primary' hues (red/yellow/blue). Kandinsky believed, in addition, that relationships existed between the 'primary' colours (red/yellow/blue), the 'primary' shapes (circle/square/triangle), and the 'primary' angles (right-angle/acute-angle/obtuse-anlge).

Sir Isaac Newton favoured the corpuscular theory, while advocates of the wave theory included Descartes, the mathematician Euler, Christian Huygens, and the poet Goethe. Huygens, a key figure in the formulation of the wave theory, is well known for his classic study of Iceland spar, a transparent, crystalline mineral which transmits a double image of any object viewed through it, a characteristic termed 'double refraction'. If through a crystal of Iceland spar, a dot on a sheet of paper is viewed, it will appear as two dots; if the crystal is then rotated, one dot will remain stationary, while the second travels a circular orbit around the first. Through his studies of this phenomenon, Huygens discovered, but was unable to explain, the polarization of light, a phenomonen which was more deeply investigated during the nineteenth century.

A violent opponent of Newton and the corpuscular theory, the poet Goethe devoted twenty years to intensive optical researches, beginning his investigations of colour from a study of painter's pigments and from consideration of questions of colour harmony in painting. He was especially interested in such ephemeral colour effects as optical illusions, after-images (for which he gave a correct physiological explanation), and complementary colours in shadows. Interested in the colours of, and in the manufacture of, opalescent glass, he unearthed several old recipes for such glass from medieval books such as Kunckel's *Art of The Glazier*. An adjunct to his study of colour, and today considered a classic in its field, is Goethe's series of historical essays detailing the development of colour theory. The first section of this history details developments in colour theory from antiquity to the end of the seventeenth century; the second section, from Newton to Goethe's own time. Goethe began his optical experiments in 1790, and two years later published an essay 'On Coloured Shadows'. When the full results of his researches were published in 1810, Goethe's theories were rejected by physicists, and fell into almost complete oblivion during the nineteenth century. A few physiologists were impressed, among them Johannes Muller, founder of

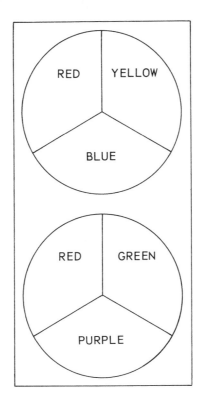

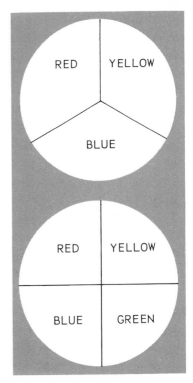

14. Two theories of the 'primary' colours. Thomas Young (1773-1829) discovered that various colour sets, each set containing not less than three colours, could be used to create all colours appearing in the solar spectrum. Speculating that the eye must contain at least three types of colour receptors, Young first suggested these receptors would be sensitive to red/yellow/blue. Later, he modified his hypothesis, suggesting red/green/purple as the primary set.

15. Two theories on the 'primary' colours. In attempts to understand colour vision, red/yellow/blue were originally suggested as the basic or 'primary' colours. Later, conjecture favoured red/yellow/blue/green. It may be that neither view is correct, for research by Edwin Land, inventor of the polaroid camera, suggests that two coloured lights may yield one end colour result when mixed in simple patches, yet yield a different end colour result when mixed in small particles or complex patterns.

the science of physiological optics. Impressed also, at a later date, was Moholy-Nagy, who wrote, 'Goethe is altogether a masterly teacher of psychophysical optical effects, and I believe that we shall often refer to him during our future researches'. Today, when the ephemeral and illusory colour effects which interested Goethe are beginning to play an increasingly important role in the iconography of art, his researches are indeed of interest to the artist.

Associated with Goethe in some of his colour research was his intimate friend the Romantic painter Philip O. Runge who, while he shared Goethe's interest in the scientific study of colour, felt strongly that the symbolic aspect of colour was of equal importance with the scientific.

16. Jules Olitski. *Julius and Friends*. Acrylic on canvas. 1967, 71 1/2 x 149 3/4". Private Collection. Photo courtesy of Andre Emmerich Gallery.

17. Ad Reinhardt. *Red Painting No. 7*. Oil on canvas. 1952, 76 x 144". Photo by Kenneth Campbell, reproduced by permission of Mrs Ad Reinhardt.

INFRA-RED

RED

ORANGE

YELLOW

GREEN

BLUE

VIOLET

ULTRA-VIOLET

Knowledge available at the end of the seventeenth century was insufficient to give an answer to whether the wave theory or the corpuscular theory gave a better explanation of the nature of light; very few further discoveries of importance were made until, at the beginning of the nineteenth century, Augustin Fresnel evolved the basis for the theory of light held today. Fresnel expanded the work of Thomas Young, who suggested that light might be waves, but waves of a different type than had previously been conjectured. Fresnel's work suggested the wave theory to be clearly superior to the corpurpuscular theory, but in 1905, Einstein re-introduced the corpuscular theory with the suggestion that light consisted of tiny particles called photons, whose characteristics he delineated. The theory of relativity, quantum mechanics, and the development of the mathematical theory of waves have raised the wave/corpuscle conflict to a more sophisticated level which is much more difficult for the non-physicist to understand. Yet in a certain sense, the classical conflict about the nature of light which began in the seventeenth century still remains unresolved. In 1860, James Clerk Maxwell had identified light with electric waves, and the current view on the nature of light is that it occupies a

18. The position of the spectral colours on the electromagnetic wave scale. The closer a colour lies to infra-red, the more 'warm' the colour is said to be; the further the colour lies from infra-red, the more 'cool' the colour is said to be. 'Warmness' and 'coolness' are relative qualities referring to the position of the spectral colours on the electro-magnetic wave scale. Thus, red is 'warmer' than orange, which is 'warmer' than yellow, which is 'warmer' than green . . . etc. Infra-red is invisible to the eye, but affects camera film.

intermediate position on the wave scale: under some conditions, light behaves as if it were a series of waves, while under other conditions it acts as if it were a stream of corpuscles. Recently, Einstein's relativity theory has been challenged, and if it is indeed proved to be insufficient, physicists will perhaps again have to modify their view on the nature of light. A tendency to the apotheosis of 'science' characterized the nineteenth century and, apparently, affected even the Impressionist painters: engaged in what then seemed to be radical colour experiments, the Impressionists justified their stance through the assertion that their use of colour was based on 'scientific' truths. Today, the artist feels less compelled to justify his way of working by claiming to be 'scientific', and interchange between art and science exists in a differing context.

Today, many artists feel strong interest in the new scientific technology, and in the possibilities it affords for extending the traditional media of art. Painter Billy Apple, and film-maker Robert Whitman, have both worked with the laser beam, a light beam which does not diverge; Apple has suggested possibilities for the laser-formed hologram as a potential art medium. Also of interest is *Experiments in Art and Technology*, a group formed for purpose of encouraging collaboration between artists and engineers. Access by the artist to the media of a new technology opens up the possibility of creating works which utilize not only laser beams, but also infra-red or ultra-violet. This, in turn, may eventually force a total re-definition of the concept of 'colour'.

It seems apparent that confining the idea of 'colour' to the colours of the solar spectrum is too narrow an approach. And defining a colour as more or less 'pure' in accordance with how closely it approaches one of the spectral hues, is of no practical value. But, perhaps, it may also be that our notion of a 'spectrum' that ranges from red to violet is also too narrow. Perhaps both infra-red and ultra-violet (which occur in the solar spectrum) should be accorded a place on the 'colour wheel', and perhaps they

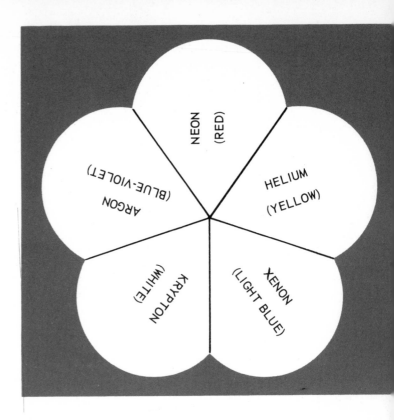

NEON
(RED)

HELIUM
(YELLOW)

ARGON
(BLUE-VIOLET)

KRYPTON
(WHITE)

XENON
(LIGHT BLUE)

19. Neon is only one of several gases used in incandescent 'neon' lights or 'neon' sculpture; the colour obtained is dependent on the gas used. The five gases shown on this chart (along with the colours they produce when heated to incandescence) are all inert elements which enter into absolutely no chemical compounds whatever. Mercury vapour produces a white light, with high ultraviolet content.

20. Chryssa. *Fragment For The Gates to Times Square*. 1966 Neon and plexiglass. Chryssa is one of several sculptors who have incorporated into their work the colours of incandescent 'neon' lighting. Photo courtesy of Pace Gallery.

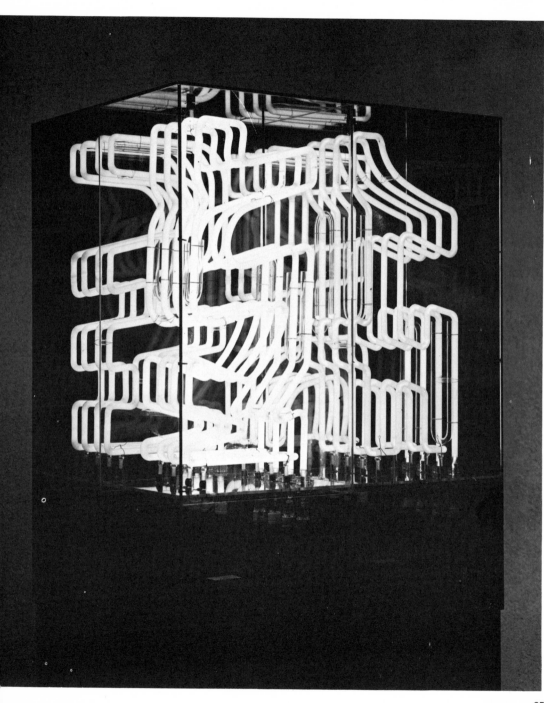

will eventually become part of the 'palette' of the artist. Both of these 'colours' (infra-red/ultra violet) are not directly visible to the human eye but may be 'seen' indirectly, through their effect on such grounds as camera film. While it may seem odd to speak of colours which cannot be 'seen', we have come to speak quite easily of—for instance—'super sonic' *sound*, which we define as sound which cannot be 'heard'. The concept of 'super-ocular' colour is, perhaps, neither more nor less strange than the concept of 'supersonic' sound.

The way, at any rate, would seem open for more speculation about colour for more experimentation, and for attempts to further break with tradition al stereotypes and conventional ideas. The great changes which have occurred in our views about colour during the past several decades may be only the foundation for even greater changes which will occur in the future.

5. The use of colour in contemporary art

Colours, the materials of the painter; colours in their own lives, weeping and laughing, dream and bliss, hot and sacred, like love songs and the erotic, like songs and glorious chorals! Colours in vibration, pealing like silver bells and clanging like bronze bells, proclaiming happiness, passion and love, soul, blood and death.

Emil Nolde[5]

Today I have a concept of colour which I never even thought of before. Now I think of it as another element like line and space. I think of colour as an interval of space—not as red or blue. People used to think of colour and form as two things. I think of them as the same thing, so far as the language of painting is concerned. Colour in a painting represents different positions in space. In drawing with colour up and across you have also drawn a certain distance in relation to the polar extremes of the constants of the colour solid. Colour conceived in this way becomes a space or length interval. If you have monotony in the length of these intervals you have monotony in colour. I believe colour relations are not merely personal, but objectively true.

Stuart Davis[6]

A changing assessment of the role of colour underlies the development of contemporary art since the era of the French Impressionists. Colour, previously subservient to form, assumed by gradual stages a role of prime importance. Today, colour in art is not usually regarded as an embellishment for form but, rather, as the essential material from which form is created. This changed attitude towards colour has been called the most important development of the contemporary era by Stuart Davis, who wrote, 'Modern art differs from art of the past not in its abstractness, but in its new and contemporary concept of colour-space or form'. This changing role of colour in art has keynoted a general revolution in human thinking, leading to a greater respect for the visual world, and for the modes and laws of visual perception. Today, colour in art is most often used for the direct perceptual sensations it can evoke. Colour is less often used as symbol, and is less often used as imitation.

5 Protter, *Painters on Painting*, p. 179

6 James Johnson Sweeney, *Stuart Davis*, New York, 1945, p. 33

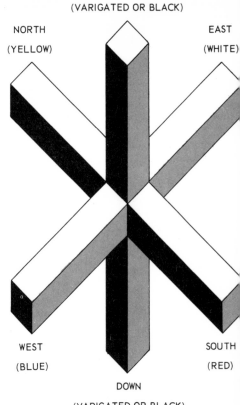

UP

(VARIGATED OR BLACK)

NORTH

(YELLOW)

EAST

(WHITE)

WEST

(BLUE)

SOUTH

(RED)

DOWN

(VARIGATED OR BLACK)

21. Pueblo Indian colour symbolism. The Pueblo Indians of the American South-west evolved a system of colour symbolism in which colours were signs for the various compass directions. The exact colours used varied somewhat in differing locales; to some Pueblo groups, West was yellow, South was either blue or buff, and North was either black or blue. Use of colour as a sign for direction is common to all Pueblo tribes.

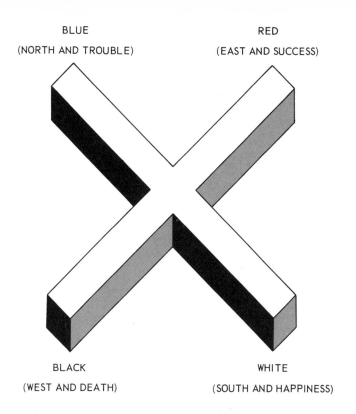

BLUE
(NORTH AND TROUBLE)

RED
(EAST AND SUCCESS)

BLACK
(WEST AND DEATH)

WHITE
(SOUTH AND HAPPINESS)

22. Cherokee Indian colour symbolism. To the Cherokees, colour indicated the various compass directions, and also presaged the future.

The move away from colour as symbol: Colour symbolism—like any other type of symbolism—tends to set up a world of 'meanings', a semantic shadow world separate from the real world of colour. For this reason Moholy-Nagy expressed the hope that the art of painting might someday free man from symbolic associations with colour by emphasizing—and thus conditioning man to—the direct sensuous impact of colour. Moholy Nagy's vision in this regard may be Utopian, but his insight into the anti-perceptual nature of colour symbolism is valid and pertinent today Colour symbolism has less to do with colour than it has to do with language, and the linguistic basis of colour symbolism is analogic consider, for instance, the very common suggestion that 'red symbolizes fire'. This symbolic connection presumably suggests itself because red and fire are alike in one respect: both contain 'redness'. The relationship suggested between red and fire because they have 'redness' in common is relationship by *analogy*, or relationship by virtue of similarity in some particular aspect. Some form of analogy underlies most symbolism—including colour symbolism. Yet the purpose of analogy—the function which so endeared it to the nineteenth-century Romantic and Symbolist literary movements—is to avoid direct response or objective description and to beg the rigorous question of what an entity *is* by substituting an endless stream of suggestions about what the entity *is like* ('O my Luve's like a red, red rose . . .'). The analogy 'red is like fire' communicates less data about red than do far more humble statements such as 'red looks brighter next to black', 'red is one of the colours of the solar spectrum' or 'red is not blue'. Language is opaque at best; its present capacity to communicate colour data is excruciatingly limited; definitive verbal descriptions of individual colours cannot be articulated. Yet it is still necessary to recognize that analogy, when put forth as verbal colour description, confuses rather than clarifies the problem of colour analysis Extreme examples of colour description by analogy clarify this even more forcefully. The statement, 'The paint I bought today is exactly the same colour as the paint I bought yesterday' is a perfect description by analogy

23. Egyptian dream symbolism, based on colour. The ancient Egyptians are said to have attributed significance to the colour which appeared to be most prominent in a dream. If any colour appeared mixed with black (in stripes, checks, or patterns), the dream acquired the reverse significance of that attributed to the plain colour: thus, brilliant red signifies ardent love, but brilliant red mixed with black signifies hatred. (After Tungwelt and Gutheil, *Thesaurus of Dreams*).

BLACK: Death of someone close to dreamer

DARK BLUE: Success.

ROYAL BLUE: An order will be imparted to dreamer.

PALE BLUE: Happiness.

BROWN: Sadness and danger are imminent.

LIGHT GREEN: Bad omen.

DARK GREEN: Serenity, gaity.

PURPLE: Sadness.

BRILLIANT RED: Ardent love.

DARK RED: Violent passion.

LIGHT RED: Tenderness.

DEEP VIOLET: The dreamer will acquire power.

PALE VIOLET: The dreamer will acquire wisdom.

DEEP YELLOW: Jealousy and deceit.

PALE YELLOW: Material comfort.

WHITE: Happiness in the home.

yet communicates absolutely nothing about the nature of the colour in question. The analogic or symbolic connection between red and fire further dilutes perception of red by tempting people to think of fire and red at the same time. This divided perception leads to a complicated train of mental association in which ideas relating to fire become hopelessly entangled with the simple perception of red. Many people claim, for instance, that red is 'too hot' a colour to wear during the summer months; such people are substituting their ideas about heat or fire for their perception of red. The colour red does not 'look hot' unless the suggestion of a connection between red and fire, or red and heat, has previously been implanted in the mind. Response to colour symbolism is response to colour pre-conception, and is pre-determined response based on literary and psychological ideas about colour, rather than response to the nature of colour itself. In part, man feels impelled to create symbols—and to impute symbolic connotations to colour—because he cannot help allowing his feelings and emotions, his literary, psychological and intellectual preconceptions, from interfering with his direct perception of the physical world. Colour fashions, colour traditions, and colour conventions are all specialized forms of transitory colour symbolism, and are determined by the conventional preconceptions of a society, not by its colour perceptions. These fashions, traditions, and conventions have lives of varying duration. A colour may be considered highly fashionable for only a few months, and then lose the connotations which made it seem so desirable. Other trends in colour taste—such as the belief that black was the only suitable colour for the clothing of elderly women— may last for many generations. Colour fashions, traditions, and conventions assume a negative aspect primarily when they become unduly restrictive, and when they restrain colour choice to a range which is excessively monotonous and narrow.

Man's extremely strong impulse to create colour symbolism suggests that even if an ideal and clearly defined 'science' of colour were to be

24. Ellsworth Kelly. *Green*, *Blue*, *Red*. 1964. Oil on canvas. 73 x 100″. Collection Whitney Museum of American Art, New York; Gift of the Friends of the Whitney Museum of American Art, New York. Kelly is one of many artists currently working with flat spatial concepts and large-scale areas of unmodulated colour. Photo courtesy of the Whitney Museum of American Art.

formulated, no way could be found to provide foolproof formulae for producing 'good' colour combinations. In fact, the idea that some colours are more attractive than others may in itself be regarded as a form of symbolism, based on socially conditioned preconceptions, and varying from one society to another. Absolutely 'good' combinations of colour do not exist, and context is a key variable in determining whether a colour combination is 'good'. Bright green and orange, a 'good' combination to use at the present time in the design of women's clothing, would not have been a good combination to use for this same purpose fifteen years ago. Nor would this same set of colours be a good combination to use, today, for the design of a man's suit to be worn to the office. Quasi-scientific systems of colour categorization, such as the Ostwald or Munsell systems, even if they were not limited by their reliance on nineteenth-century physics, can never give insight into methods for producing 'good' colour combinations, for these systems have no way of predicting the symbolic connotations people may impute to colour. And where strong symbolic connotations, or strong colour prejudices, exist, these pre-judices will determine people's reactions far more than any particular qualities of colour itself. A monochrome combination of various blues may, for instance, be planned by use of the Munsell or Ostwald systems. Such a monochrome combination of blues may also be planned in several other ways, including the intuitive. But regardless of the method employed—whether the method be simple or complex, intuitive or systematic—no monochrome combination of blues will ever, under any circumstances, find favour with the Yezidi, a people who live in the Caucasus and in Armenia. The Yezidi dislike the colour blue intensely— so intensely that they curse their enemies by saying 'May you die in blue garments'. The answer to the question of why blue is considered such an unlucky colour by the Yezidi is simple: they have imputed symbolic overtones of undesirability to the colour, and therefore, to them, it is an undesirable colour. If the illogic of their belief puzzles us, *they* would perhaps be amazed by some of the colour symbolism of *our* society

aspersions are cast on a man's courage by calling him 'yellow', and doubts are expressed about his health by stating that he looks 'green'.

The precise content of colour symbolism in our own society varies greatly with context. Contemporary Europeans and Americans have been trained to remember that with traffic signals, red means 'stop', while green means 'go'. Yet *only* in a traffic situation does red/green symbolize stop/ go. In another context, red/green symbolizes the Christmas season. Single colours or sets of colours very often acquire several different—and conflicting—symbolic meanings. During the Red Guard rebellion in Communist China, some members of the Red Guard protested the choice of colours used in traffic lights, and demanded that the traditional order be inverted so that red would indicate 'go', and green would indicate 'stop'. Their specific objection, of course, was to the use of red as a symbol for 'stop'. Since red has been used as a colour symbol for Communism, the Guard found it improper that red should *also* be used to indicate a negative command such as 'stop'. It is also interesting to note that while, today, red is usually thought to be the colour symbol for Russia, or Communism, this was not so in the 1920's. In 1922, the psychologist Hermann Rorschach wrote that many of the subjects who took the Rorschach ink-blot test associated *green* with Russia; Rorschach suggested that this was because Russia was usually (at that time) coloured green on maps.

The arbitrary nature of colour symbolism is made apparent by the fact that other societies have had systems of colour symbolism which differed vastly from those of the contemporary Western world, both in small details and in overall organization. In Imperial Rome, as in Nation- alist China, white—not black—was the colour of mourning. To the Maya Indians, kings were not 'blue-blooded', but, rather, had white blood. The ancient Egyptians had a complicated system for interpreting dreams, based on the colour which appeared most prominently in the dream. In

the Old Testament, red, blue, purple, and white symbolized, respectively, the elements of fire, air, water, and earth; flames composed of these four colours symbolized the presence of God. The Pueblo Indians of the American southwest perhaps systematized colour more than any other people has ever done. One of the most interesting facets of Pueblo colour symbolism is the fact that different colours were assigned to the different compass directions. The particular colours used varied somewhat from tribe to tribe; to some tribes, yellow symbolized North, while to others North was blue or black. But the habit of assigning colours to the various compass directions is common to all the Pueblo tribes, and finds no parallel in contemporary European society, which has no colour for North, South, East, West, Up, or Down. Among the Cherokee Indians and also in Mexico, Ireland, China and Vedic India, colour was assigned to compass directions.

The move away from colour as imitation: One of the most important factors in the move (in art) away from colour as imitation has been a move away from the rendering of local colour in art, a move which began during the nineteenth century with the work of Eugène Delacroix, gained greater impetus with the French Impressionists, and perhaps reached its final culmination in Jules Olitsky, who said, during the 1960's, that he wished he could paint by spraying colours into the air. The most interesting aspect of Olitsky's vision of coloured mists is that it is a fantasy of an art freed from the object, freed from the world of defined shapes, freed from the canvas and freed from the linear configuration . . . in fact, an art disassociated from all elements except colour—colour which has no definable shape, colour which hangs in the air, alone.

The traditional view of colour as local colour, colour as an element which is subservient to form, may be found expostulated in the notes made on colour by Leonardo da Vinci. Da Vinci's notes consist primarily of rules and formulae for imitating the local colour of objects, including suggestions on how this local colour appears under different lighting and

25. Paul Signac. *View of the Port of Marseilles.* Oil on canvas. 35 x 45 3/4″. Signac became a major spokesman for the Neo-Impressionist or divisionist colour theories of Seurat. Henri Matisse, early in his career, met Signac, and was briefly influenced by divisionism; later, however, Matisse strongly repudiated the idea of breaking colour into small particles, because he felt it weakened the final colour effect. Photo courtesy of The Metropolitan Museum of Art, Gift of Robert Lehman, 1955.

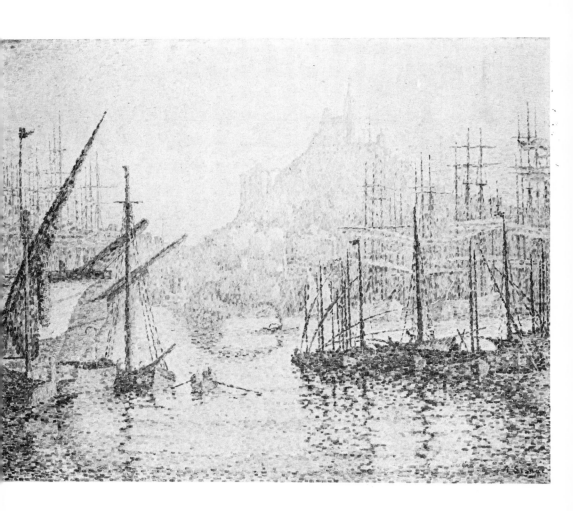

atmospheric conditions. Da Vinci reflects, in his notes, the fifteenth-century view that colour is a secondary characteristic of objects and forms, and that art is a skilful mimesis which includes imitation of the local colour of objects. While variations appear in the work of individual artists (the image evoked may be a real world or an ideal one; forms may be sharply defined or obscured by mysterious shadows), the world depicted by artists prior to the contemporary era is a world primarily concerned with the sculptural shapes and forms of the three-dimensional world. Primary concern is with the depiction of forms; colour functions primarily as the local colour of objects, not as an independent entity out of which pictures may be composed.

Because of this earlier stress on mimesis, or imitation, the word 'colour-ist' often has slightly different connotations when used in reference to precontemporary art: during the Renaissance, painters who could most skilfully capture naturalistic colours effects difficult to translate into pigment, such as the opalescent tones of flesh, were considered to be the finest colourists. Today, skill as a colourist would more probably imply skill at *composing* colours, rather than skill at *imitating* colours. The Renaissance view that colour is secondary in importance to shape (or form) finds expression in the traditional academic technique of glaze and under-painting. An underpainting consists of a monochromatic rendering, usually in black and white or terre verte and white, of the entire painting. Forms are modelled and major compositional problems are solved, in the underpainting, which is then coloured, usually with

26. Larry Poons. *Untitled*. 1966. Synthetic polymer paint on canvas. 130 x 90″. Collection Whitney Museum of American Art, New York. The dots and ellipses of this painting at first appear to be colour spots floating at random in a colour field; each dot or ellipse is, however, positioned along the axes of a grid which traverses the field. Photo courtesy of Whitney Museum of American Art.

transparent glazes of colour, sometimes with opaque colour. Whicheve
method is used, colour functions as an embellishment applied to th
surface of an already planned picture, rather than functioning as th
material from which the picture itself is constructed.

Light and colour: Da Vinci has been praised by certain artists of th
modern era (Odilon Redon, for instance) on account of the strange an
mysterious shadows which alternately reveal and obscure the form
depicted in his paintings. What is important to note is that Da Vinci'
concern is with *forms*, in their alternating conditions of clarity and non
clarity; he regards light as the medium which reveals (and obscures
forms. Later, the French Impressionists treated light as the medium whic
reveals (and obscures) *colours*. A capsule history of the changing re
lationship between light, form, and colour in art can be constructed b
comparing the relative emphasis placed on each of these elements b
Leonardo, Rembrandt, the Impressionists, the abstract-expressionis
painter Mark Rothko, Thomas Wilfred, and Chryssa. Wilfred is th
creator of the Lumia, a machine which creates changing compositions i
coloured light; Chryssa is one of the artists who creates sculpture fror
glass tubing filled with the type of coloured illuminating gas used i
'neon' signs. This capsule history (see illustration 28), which demor

27. Pierre Bonnard. *The Breakfast Room*. (c. 1930-31) Oil on canvas, 63 1/4 x 4
1/8". Collection, The Museum of Modern Art, New York. Bonnard's use of high
key colours in 'shadow' areas seemed, at first, to be radical. Yet near the begi
ning of the nineteenth century, Goethe had written on coloured shadows, an
had made reference in his poetry to the fact that green waves may have purp
shadows. Photo courtesy of The Museum of Modern Art, New York.

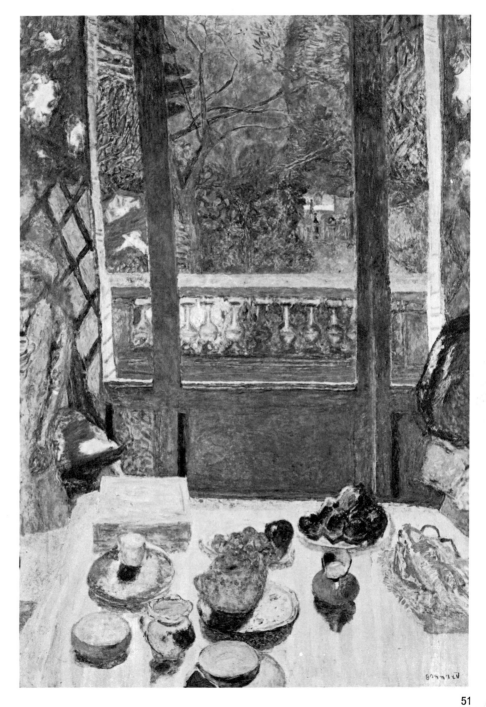

51

strates in miniature the changing stress laid on colour in art, may b
better understood if it is seen as a suggestion of how the task of makin
art has been 'programmed' by individual artists during different eras
the artist cannot re-create the world; he can only create 'art', a concret
statement about those aspects of infinite possibility which are of greates
concern to him. In this sense, art has always been 'programmed', fo
the process of making art, like any other process, begins with decision
about which factors are of vital importance, which factors are of lesse
importance, and what the relationship is between all factors. To D
Vinci, light was programmed as the vital medium which revealed *form*
to the Impressionists, light was programmed as the vital medium whic
revealed *colour*. To Chryssa, light, insofar as is practically possibl
(subject to the practical necessity of restraining coloured gases in glas
tubing), has been programmed as an entity which is identical with bot
colour and form. Olitsky's fantasy of spraying colours into the air i
simply a fantasy of articulating coloured vapours without the necessity f
restraining them by, or containing them in, glass tubes.

Renoir is credited with introducing broken colour into Impressionism
but it seems also clear that the Impressionists were influenced by th
optical theories of M. E. Chevreul and O. N. Rood.

While the Impressionists stressed the scientific nature of their concer
with colour, later artists such as Matisse have praised the Impressionist
not for their 'science', but rather for their role in revealing the sensuou
or perceptual aspect of colour. Broken colour—and the optical theorie
of the Impressionists—became codified with the Neo-Impressionist
(Seurat, Signac, Cross), who broke colour into small dots, wished to b
called 'divisionists', and protested that they did not 'dot', but, rathe
'divided'. The Post-Impressionists (Van Gogh, Gauguin, Lautrec) turne
away from the dot of colour and returned to the use of large areas of fl
colour, a tendency which had been prefigured by the earlier work

LIGHT, COLOUR, FORMS: THEIR CHANGING RELATIONSHIPS

LEONARDO DA VINCI: Light functions to reveal forms. Colour is subordinated to form and functions only as the local colour of forms (or objects).

REMBRANDT: Light functions to reveal forms. Colour assumes an independent existance and does not function solely as local colour or as an attribute of forms.

THE IMPRESSIONISTS: Light functions to reveal colours. Illusionistic representation of three-dimensional form is subordinated.

THOMAS WILFRED: Light, colour and form are one. Images on a screen are made of clouds of coloured light.

CHRYSSA: Light, colour, and form are one. Coloured light (incandescent gases in glass tubing) functions as free-standing sculpture.

28. Light, colour, form: their changing relationships.

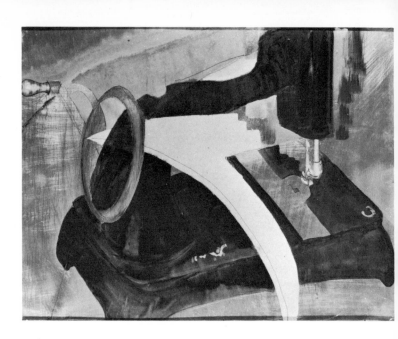

29, 30. Interest in the use of metals, and in the non-spectral metallic colours appeared early in the Modernist era and was not confined (as were earlie Byzantine icons, for instance) to the use of precious metals. Arthur Dove's *Hand Sewing Machine* (a) (14 7/8 x 19 3/4″, 1927) is a mixed media work combinin cloth and oil paint on a metal ground. Dove's *Reaching Waves* (b) (19 7/8 x 23 7/8″ 1929) combines oil and silver paint on canvas. Photos courtesy of The Metro politan Museum of Art, The Alfred Stieglitz Collection, 1949.

Manet. An interesting interplay between the dot and the plane may b seen in the colour views of many early twentieth-century artists: Matisse rejected the idea of breaking colour into dots or small particles, but som of the work of the Futurists (Boccioni, Severini, Carra) directly incorpor ates the broken colour of the divisionist tradition initiated by Seurat Today, the dot as a basic modular unit of colour has re-appeared in suc diverse artists as Roy Lichtenstein, who uses a Ben-day dot motif, and Sally Hazelet. Hazelet, whose work somewhat resembles an enlarge section of a Seurat painting, covers the entire picture plane with a singl tone of colour, a tone created by small particles of various pigments; i some of her paintings, this tonality darkens somewhat in the centre of th

canvas, creating a vortex-like effect. The dot itself, sometimes lengthened into an ellipse, always laid on a grid structure, becomes the main pictorial motif of Larry Poons.

Since the time ot Delacroix, it has by gradual stages become impossible to speak of art without beginning by a discussion of colour. Colour was a critical point in Fauvism, a critical point in German Expressionism. Maurice Denis began his *Definition of Neo-Traditionalism* (1890) by declaring that a picture was first of all a flat surface covered with an arrangement ot colours. Some artists, such as Matisse, have insisted that their use of colour is intuitive. Others, like Seurat or Kandinsky, have attempted to formulate a logically coherent theoretical base to justify

their personal use of colour. The expressionist painter Ernst Wilhelm Nay speculated on what he called 'chromatic counterpoint'. The writings of Van Gogh, Nolde, and Delacroix all display a deep concern with colour.

Today, art would seem to be moving in two somewhat disparate directions; each direction makes interesting and unique use of colour. The first direction questions whether the evocation of 'spatial' relationships is requisite in art, and rejects alike the classical Renaissance concept of perspective space, and also the ambiguous or paradoxical concept of space—a space which is at once two-and three-dimensional—which developed from Cézanne through cubism to abstract-expressionism. Among proponents of this virtually flat planar space, Ad Reinhardt creates black paintings composed of nine squares of near-black, selected for minimal colour contrast and minimal articulation of the picture plane. George Ortman composed his early paintings of many individual stretched-canvas units, each painted a different colour, which interlocked together; later, Ortman began using units of metal, rather than canvas. David Novros utilizes many small stretched-canvas units, all painted the same colour, which he composes into configurations with large interstices, so that the colour of the wall plays a role in the 'composition' of each painting. Novros is among the many artists relying strongly on the use of non-spectral metallic paints, challenging the conventional idea that metallic colours are not really 'colours'. Op art, in antithesis to Reinhardt's use of minimal colour contrast, utilizes maximal contrast, substitutes the optical illusion for the spatial illusion, and postulates a mystique of the retinal for which the colour investigations of the Impressionists provide precedent. Stain painting (Morris Louis) suggests an alternative to the plane, the dot, or the brush-stroke as a method of applying colour, and also revives possibilities for the investigation of transparent and translucent colours. Acrylic paints, which do not provide the 'painterly' surface of oil paint, have made feasible the articulation of

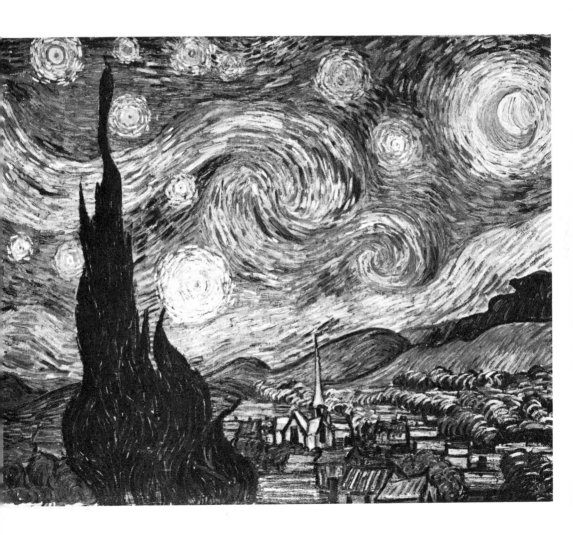

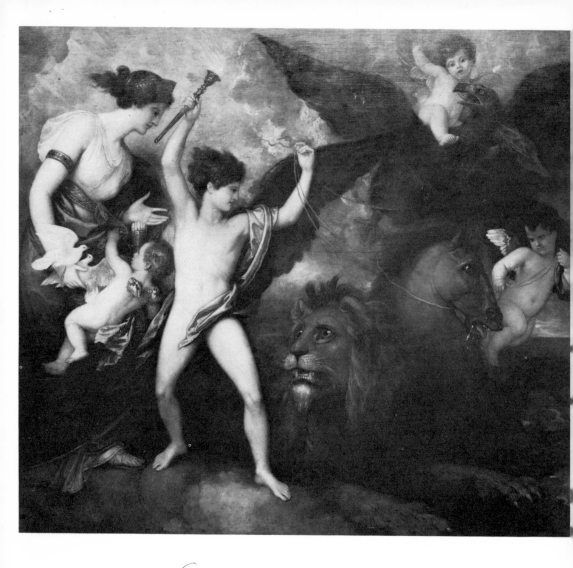

32. Benjamin West. *Omnia Vincit Amor, or Love in the Three Elements*. 1776. 70 3/8 x 80 1/2″. West, the American-born painter who became court painter to King George III, and succeeded Sir Joshua Reynolds as President of The British Royal Academy, devised what he called the 'rainbow' theory of modelling with colour. According to West, all of the 'rainbow' colours may be seen, in their spectral order, on any object, regardless of the local colour of the object; this progression of the spectral colours parallels the progression from high-light to deep shadow. West's theory is an interesting precursor to the later colour theories of Chevreul and the French Impressionists. Photo courtesy of The Metropolitan Museum of Art, Maria De Witt Jesup Fund, 1923.

flat planes of colour in which no brush-strokes show, and have also opened up the possibilities of stain painting on unsized canvas. Metallic and day-glo paints provide new colour ranges, and render obsolete any proposals about the theoretical basis of colour which rely solely on the spectral colours plus black and white. Artists today work with coloured lights (Jackie Cassen, Steve Antonakis, Chryssa), coloured plastics (David Weinrib), coloured yarns (Lucas Samaras), and transparent materials. Colour in sculpture has returned, for the first time since before the Renaissance. In Andy Warhol's *Chelsea Girls*, and in other cinematic experiments by artists, colour on the motion picture screen has been released from the object; figures walk, talk, and ultimately dissolve into puddles of colour which move erratically about on the screen.

The use of colour in contemporary artifacts

As the reader has no doubt noticed, our present society is a mixed society in its attitude towards, and tastes in, colour; two diametrically opposed points of view are found. Many younger people love vivid colour. Many older people do not, for they were trained in their own youth to a differing set of attitudes about colour. An understanding of both newer and older viewpoints, and how each has affected the colour-styling of manufactured objects, is of key importance to the designer.

It is apparent that the new approach to colour is not simply a casual interest in—or a temporary fashion for—*bright* colours. Rather, what has appeared is a completely different stress—an intensified stress—on the importance of colour itself. This new stress is manifested in both a quickened interest in the colour-styling of manufactured objects, and a different manner of thinking about this colour-styling. During the past twenty years, the designer has ceased to treat colours—especially bright colours—as a sort of surface decoration to be applied to clothing, objects, or interiors in judiciously small touches. Standardization in colour usage is less common, and less rigid; colour today is most often regarded as an integral part of objects themselves. Literally, in the case of plastic objects, colour may become a quality which permeates the entire object, and does not merely lie on the surface.

33. An experiment with colour in urban planning (tenement building at 312 East Tenth Street, New York City). Artists Alan d'Arcangelo and Robert Wiegand were commissioned by city-planner and public engineer David Bromberg to paint on, or design, the exteriors of slum buildings which were under renovation. Wiegand's façade, shown here, is permanent green light and ultramarine. Commercial oil paints were used on the cornice, acrylics on the remainder of the façade. Photo by Robert Bolles.

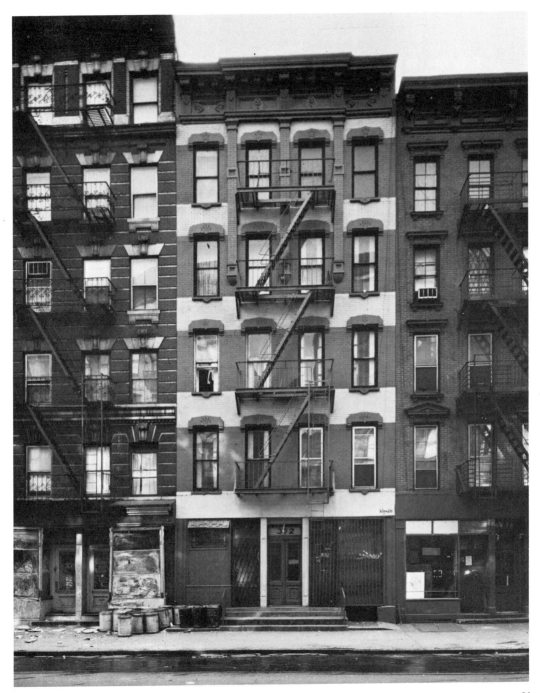

34. Henri Matisse. *The Red Studio.* (1911). Oil on canvas, 71 1/4 x 86 1/4". Collection The Museum of Modern Art, New York, Mrs Simon Guggenheim Fund. Use of large areas of bright red—as in this painting—was often considered vulgar during the late nineteenth and early twentieth centuries. Yet earlier art—Pompeiian wall paintings, for instance—had made use of large areas of unmodulated red. Photo courtesy of The Museum of Modern Art, New York.

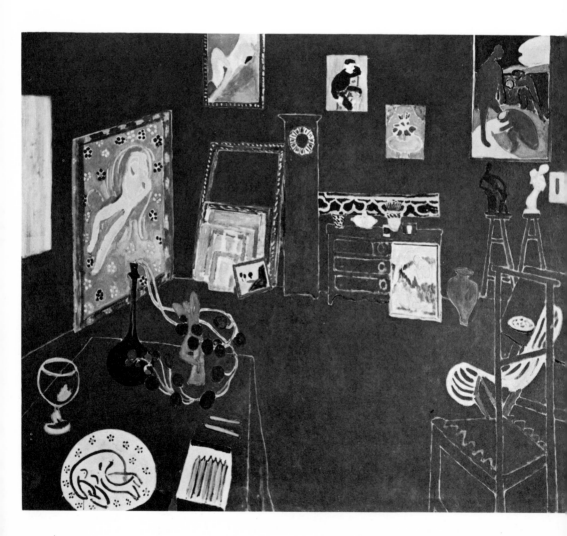

If the designer is to use colour in a vital manner, it is essential that he be aware of the ways in which contemporary colour freedom—and the demand for individualized colour choice—manifests itself. Old colour habits and colour conventions are crumbling; old modes of thinking about colour are disappearing.

Many books published fifteen, twenty, or more years ago—books which have the purpose of informing designer and public on the use of colour in clothing, interiors, and manufactured objects—are hopelessly obsolete today. These books, dealing with topics such as colour in home planning, or colour in clothing design and selection, are not—by today's standards—books on colour at all. Rather, they are historical documents which delineate the aesthetico-social mores, and reveal the *etiquette* of, a past era. When such books speak of colour, their main intent is to delineate a 'proper', or 'tasteful', range of colour choice which the prudent individual is not expected to exceed. Providing formulae for the decoration of living-rooms in various beige, tan, and brown monochromatic schemes, these books—more importantly—implicitly insinuate that the individual who exceeds this monochrome range—and designs his living-room in scarlet/purple/cerulean/jet, for instance—has been guilty of 'loud' or improper taste. These books project the colour timidity of a bygone era, including a strong intent to standardize colour usage and minimize individual colour choice. Not only is the dissenting individual (who might want an orange/blue living-room) threatened with social opprobrium for his 'tastelessness', but 'science' is invoked to defend fancies for which no scientific basis exists. Pseudo-science and pseudo-logic defend the position that blonde women must wear one set of colours, brunettes another; colours must not be worn by red-heads or by stout people, and only a very few colours are 'appropriate' for the aged. These books solemnly assure women—and men—that if they do not select the 'proper' colours for their age, body-weight type, and hair-colour type, then their skins will take on a green colour, their complexions will

appear sallow, and their friends will find their appearance totally unat-
tractive. Perhaps the shattered remnants of nineteenth-century absolu-
tism and Victorian repressiveness determine the format of these older
colour books; their obvious intent is to determine and standardize a
'right' colour or colour range for every occasion, so that individualized
colour choice may eventually be rendered both superfluous and impos-
sible. Today, by contrast, individualized colour choice is the basis of
taste. A broad range of colours is demanded in manufactured objects.
Designers are expected to have a highly developed and original sensi-
bility to colour. Individualized colour tastes are expressed in the homes
and clothing of everyone. Imaginative sensibility in the use of colour is
valued more highly than mere awareness of the narrow conventions of
colour 'tastefulness'. *Imagination*, today, is of more importance than
'tastefulness'.

It may appear, at first glance, that the totally uninhibited—or almost
completely non-conventional—use of colour in clothing is confined to
and will remain confined to, the clothing of children and young people.
More probably, the completely free use of colour in clothing will eventually
pervade all sectors of society, even the most conservative. [7] It is, in fact
through children and young people that this further release from conven-
tional colour inhibition will probably occur; many young men, accustomed
to the high-style colours of Mod clothing, will probably one day enter the
business world, as did their fathers. But they, in contrast to their fathers,
are less likely to be satisfied with the narrow, restricted range of colour
choice currently available in men's business suits.

7 Black is often thought to be the only 'appropriate' colour for the clergy to wear
on a daily basis. The Pope, however, dresses most usually in red (sometimes in
white). Perhaps Henri Matisse's brilliantly coloured designs for church vest-
ments will eventually inspire a complete re-evaluation of colour and design in
traditional ecclesiastical and clerical clothing.

35. Jacob Grossberg. *Yellow Ochre*. 1967. 97 x 55 1/2 x 55″. Colour is one of the most interesting developments in contemporary sculpture. This welded steel piece is coloured with brushed metal primer. Photo courtesy of Rose Fried Gallery.

Many adults, uncertain whether or not they wish to break away from the colour restraints and colour habits imposed on them in their own youth, dress their very young children in colours which they, the parents, would be reluctant to select for their own garments; in this way, such adults open the door—whether they have considered the matter or not—to changes in the mode of thinking of the next generation. It seems certain that the infant who goes to school dressed in a yellow vinyl tunic, green leotards, and red shoes, will grow up with a new and uninhibited point of view towards colour, and will have less timidity in the colours he selects for his own clothing for the rest of his life. In their toys, in their class-rooms, today's young children are, from their earliest years, surrounded by a brightly coloured environment which many older members of society never experienced.

What this means to the designer is hard to analyse in its totality, for rules are normally inferred from events after the events have happened and not while they are in process of occurring. What seems apparent is that most of the former rules for using colour, particularly those injunctions which defined certain colour ranges as 'dignified' or 'appropriate' for one or another purpose, are either quite obsolete, or can no longer be considered infallible guides. Those rules which veered most towards the quasi-scientific in the statement of their premises—the rule that certain colour sets 'clashed', or were inherently offensive, for instance —seem the most obsolete of all.

36. Chair, designed by Pierre Paulin, is covered with 'Sundown', a Caprolan nylon stretch knit fabric by Jack Lenor Larsen. Photo courtesy of Jack Lenor Larsen.

Colour usage rapidly strips colours of negative connotations. Many individuals asserted, a few years ago, that the day-glo or fluorescent colours hurt their eyes; perhaps, very often, these were the same individuals who found the day-glo colours 'vulgar' because of their resemblance to the 'glaring' colours of neon signs. At present, the day-glo colours are used for a variety of purposes, and in a variety of objects. It seems unlikely any physical basis existed for the claim that they glared to a degree which hurt the eyes; many staid, conservative municipalities have—with great good sense—begun to use these fluorescent colours for road signs, where high visibility is a distinct functional asset. Some people claimed these colours glared so much it was impossible to look directly at them; today, these same people look at highway directional signs painted in day-glo colours, and have forgotten that the colours initially distressed them.

Changes in our openness or receptivity to colour have been pervasive enough to affect not only our colour choices, but also our verbal habits folk-lore, and social customs. People do not, as much as they used to tell jokes which hinge on a man wearing a 'loud' necktie; it seems, today less certain what the proscribed range is for a man's necktie colours And, most certainly, it no longer seems a horrible and unforgivable breach of etiqette if a man chooses to wear a more brightly coloured necktie than his neighbour.

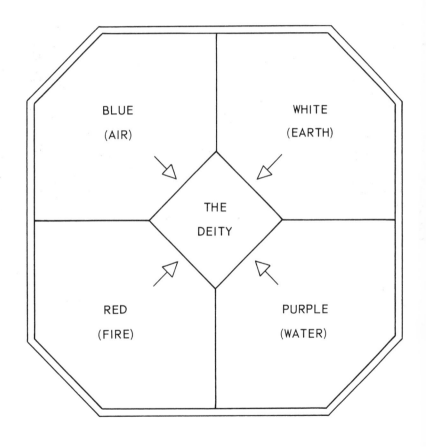

37. Colour symbolism in the Old Testament. Colour symbolized the four elements, and a Midrash story (Bamidhbar Rabbah xii) indicated that red, blue, purple, and white fires—collectively—symbolized the Being of God.

38. Coloured pedestrian cross-walks in Rutland, Vermont (USA). Léger sugges-
ted, and discussed with Trotsky, a Utopian vision of a city in which strong
colours—even spectral colours—were freely used in architectural exteriors and
streets. Efforts in this direction have in general been far too conservative. These
coloured cross-walks, in the small town of Rutland, are one of the very few exam-
ples of creative colour experimentation to be seen in American urban planning.
Photo courtesy of Rutland, Vermont, Chamber of Commerce.

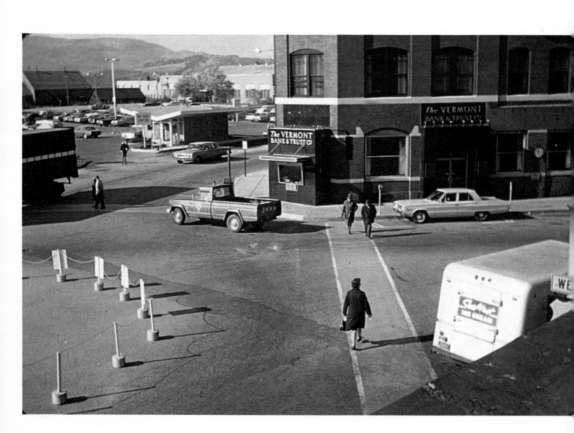

Rooms, streets, cities, provide the man-coloured environment in which almost all members of our society spend most of their waking hours. The colour of this environment is the sum total of a near infinite nember of colour decisions—good, bad, indifferent—made by a miscellaneous group of persons. Every man-made object represents a colour choice of whoever made or designed the object; the choice may have been either good or bad, either planned or indifferent, either imaginative or boring, either functional or merely conventional. In its formal sense, interior colour styling falls into two categories: residential and commercial. The colour styling of residential interiors is most often an informal expression of the personal colour tastes of the occupants; even when a designer is commissioned to provide plans for a residential interior, he generally attempts to correlate his use of colour with the personal tastes of his clients. By contrast, the commercial interior is more likely to reflect the designer's own views on environmental colour and its functioning. The type of colour standards which ought guide the designer of commercial interiors is to some extent problematical, but it would seem requisite that the designer be aware of changing standards of colour use in the *home*. To a great intent, use of colour in the home is a pivot point which determines individual response to colour use elsewhere. Many conventions which formerly determined colour use in the home have disappeared. In addition to a move away from monochromatic orientation in room planning schemes, it is important to note that many articles of home equipment which once were colour-standardized are standardized no longer; colour choice is available where previously no choice existed. Cooking pots and pans are currently made in flame orange, cerulean, crimson, green, or yellow; formerly, convention dictated that no colour be applied to these (metal) objects. Plastic and ceramic dinner dishes are available today in almost any colour; the standard white of the past—sometimes relieved with applied decorative motifs—is no longer mandatory. Rationalization formerly suggested that kitchens and bathrooms —and the equipment in these rooms—would not look 'clean' in any colour

except white. The predilection for white kitchens and bathrooms passed, at a later date, into openness to the use of pastel colours in either room; finally, the ban against bright colours in kitchen or bathroom equipment passed completely away. Today, use of bright colours in these rooms—and in plumbing equipment—is more the rule than the exception. The custom of styling nurseries and rooms for small children in pastel colours disappeared largely as a consequence of studies indicating that young children like bright colour.

The problem of exactly what sort of colour adults like is a more difficult one, for perhaps many adults do not themselves know what their colour preferences are, still less whether these preferences are personally determined or conventionally learned. Industrial interest in colour styling has led to interest in studies of colour preferences in adults. Sometimes, such studies are referred to in conjunction with office or factory design, or in conjunction with the design of office or industrial equipment. These studies, and related attempts by industry to understand what is perhaps erroneously called colour 'psychology' can be of only limited use to the professionally trained designer or colour stylist. Certainly such studies are self-defeating if attempts are made to infer excessively broad generalities from their results. Research centering on the effect of environmental colours on work performance ought always to differentiate—and sometimes does not differentiate—between long-term and short-term work performance. Most probably an individual can work quite well for a short

39. Will Barnet. *Woman Reading*. 1965. Oil on canvas. Collection Arthur A. Houghton, Jr., Steuben Corning Glass. While flat colour and flat spatial concepts are often associated with either 'minimal' art or geometric art, they may also be found in contemporary figurative art. Photo courtesy of the artist and Grippi-Waddell Gallery.

initial period in an office which is oppressively dull and uninteresting in colour; incentive for work may even be provided by desire to ignore, or blot out perception of, the boring surroundings. Yet in the long run, the effort required to ignore dreary surroundings cannot be sustained hence long-term work performance probably suffers in a monotonously coloured environment. Conversely, surroundings which are extremely attractive in colour might conceivably cause an initial period of concern with the surroundings themselves, thus temporarily distracting from attention to work; yet in the long run well-selected environmental colour most probably leads to superior performance. There is, in addition, a more subtle level on which studies and statistics correlating environmental colour and work performance may be misleading, or mistaken in format. The designer must recognize, if the industrial psychologist and the statistician do not, that colour studies centering to too great a degree on people's *work performance*, rather than their *colour preferences* have undertones of malevolence which verge on 'brain-washing'. It is unfortunate for the employer if his workers believe the colour of their office has been selected for the purpose of making them work harder; a certain percentage of people will resent, and automatically have a bad response to, any colour whose use they believe to be manipulatory.

Colour does not lend itself to coercive purpose, nor should a cloud of quasi-science be permitted to obfuscate the simple central fact that people work more efficiently in decent and attractive surroundings; the function of the colour stylist is to create such surroundings.

The key to a philosophy of office colour styling most probably lies in appreciating the relation between the use of colour in the office and the use of colour in the home; sensible colour styling might well begin with the intent to make the office as imaginative in colour as is the home.

At issue here is the psycho-social question of individuality. Most persons value the feeling of being unique individuals, and regard the home as an arena for expressing this individuality. Tendency to value personal

individuality has probably been accentuated by the generally conceded fact that any individual does, in fact, spend large portions of his life as a number, a cog, a nameless face in a crowd of faces. Most people will accept the role of non-individualized anonymity for short periods, when they sense it as requisite to a specific social end, but nonetheless resent being continually treated as faceless automatons when no apparent necessity for such treatment exists. Most persons, in particular, wish to feel that they function on their jobs as unique individuals, not as mechanistically interchangeable employees valuable only to the degree that they are standardized. The office, when it is markedly less attractive in colour than the home, suggests to the employee that he is considered to be a dehumanized cog, devoid of normal taste and feeling. In conjunction with this, it is highly significant that, today, in the offices of high-level corporation executives, the use of colour most nearly approaches the use of colour in the home. In addition, the overall interior design of such offices closely parallels the design of residential interiors, making use of flowers and plants, paintings, sculpture, rugs, and well-designed pieces of contemporary furniture. The offices of many company presidents, sophisticated and elegant in their use of colour and in their overall styling, are in sharp contrast to the austere, monastic, and institutional-looking offices which were fashionable for such executives years ago. It is highly probable that in the future this tendency to regard the office as an extension of the home will become more common, and distinctions between residential and commercial interior design or colour styling will be of less consequence.

It would seem, incidentally, unnecessary for the designer of office or industrial interiors to place undue stress in his colour decisions on the matter of whether male or female employees will work in the office being designed. The myth that women have markedly different colour preferences to men would seem to be based on conventions of the past rather than empiric evidence. Many stereotype ideas about alleged

differences in colour preference between the sexes have disappeared
it is significant that few comedy-movies today invoke the traditional
stereotype of a wife who furnishes the master-bedroom in rosebud pink
and white: counter to this once-often-depicted cinema wife with her
'feminine' colour tastes was the gruff cinema husband who despised
pink-and-white, and who fled to his basement study where he sat in his
brown leather chair in his all-brown room. Such situation comedies
are less humorous today, because it is realized that all women do not
prefer pink-and-white; it is realized that all men do not prefer neutral or
achromatic colours. And it is apparent that there is little—if any—inherent
difference in colour preferences between men and women.

Studies of how people respond to colour in an office environment (or
elsewhere) should incorporate some awareness of colour-novelty versus
colour-boredom; provision of an optimal amount of colour variety is
probably of more consequence than the absolute nature of the colour
or sets of colours selected. Colour exists in a constantly shifting context
which nullifies absolutist decisions. If, for instance, it were demonstrated
that most people prefer bright green to all other colours, it would none-
theless be most unwise promptly to paint almost all offices the same
bright green. If bright green were known to be the colour used in almost
all offices, the majority of people would begin to dislike the colour. Bright
green would be referred to as 'that horrible office colour', and its original
favorable connotations would be destroyed by over-use. Soldiers recently
released from the army often express a dislike for olive-drab, presumably
more a consequence of over-exposure than of any inherent quality of
olive-drab itself.

40. David Novros. *Untitled*. 1967. Acrylic lacquer on dacron. 8 1/2 x 6 ′. Novros'
one-colour, shaped canvas incorporates the wall and its colour into the 'compo-
sition' of the painting. Photo courtesy of Dwan Gallery.

The effect of colour in certain specialized rooms is hard to evaluate for lack of well formulated ideas of the specific function colour is intended to serve in that particular type of room. In museum rooms, for instance, successful use of environment colour is dependent in large part on sensitive analysis of exactly what one wishes to do with colour. In one major museum, each wall of a room is painted a different shade of grey, thus obtaining the advantage of a neutral wall colour (which does not distract from paintings), yet avoiding the prison-like connotations which large expanses of only one grey might have created.

A well-known art dealer put red wall-to-wall carpeting on the floor of his gallery, and was criticized for creating a colour environment which conflicted with the viewing of art; the carpeting was later removed.

Another museum has hung brown-toned curtains behind all of their Rembrandt paintings, apparently on the grounds that the brown curtains 'correlate' with the brown tonality of the Rembrandts; yet some people interpret this as a presumptuous suggestion that the Rembrandts need to be 'improved' by creation of a specially coloured environment. Hence, the colour of the brownish curtains has proved controversial.

41. Nicholas Krushenik. *Red, Yellow, Blue, Orange*. 1965. Synthetic polymer paint on canvas. 87 x 71 1/4″. Collection Whitney Museum of American Art, New York; Gift of the Friends of the Whitney Museum of American Art, New York. Krushenik's use of colour, in his black-outlined forms, has focused on major spectral hues, used at full chromatic intensity. Photo courtesy of the Whitney Museum.

Hospitals have been quick to realize the more gross practical values of colour planning, and concomitantly slow to recognize the psycho-social aspect of colour as an environment. Green has been adopted for hospital operating-rooms on the grounds that it reduces eye-strain; doctors interns, nurse's-aides, trained nurses, are distinguished one from another by the colours of their uniforms. But patient's rooms are still painted in white or pastel tones, presumably on the theory that bright colours could be 'over-exciting'. The question of whether less monotonous colour in hospitals would be 'over-exciting' or 'wholesomely stimulating' is problematic. Experiments in sensory deprivation would seem to suggest that too little stimulation may be as deleterious as too much.

Here, again, colour-use in the home is perhaps a critical determinant drastic changes in the colour appearance of the normal home environment probably have affected changes in current response to the subdued colours of the hospital environment. When the patient is transferred from the attractively coloured environment of the home to the muted pastel world of the hospital, it is indeed questionable whether he finds the pale colours soothing . . . or a depressing reminder that he has been removed from his normal life.

In 1946, Fernand Léger, speculating on problems of colour in modern architecture, suggested, 'Why not undertake a multi-coloured organization of a street—of a whole city?' Colour does indeed present itself as the obvious tool with which to ameliorate the grey and depressing appearance of most major cities. In some South American cities, the sidewalks are composed of coloured mosaics, and perhaps a variation of this concept might be adopted. Concrete is easily coloured, and if the main avenues of major cities were coloured red, or others some other distinctive colour the ends of both aesthetic function and directional orientation would b

served. There is, further, today, no reason a sky-scraper cannot be purple, turquoise blue, or yellow; architecture is no longer bound to the greys and browns of brick, stone, concrete, and other traditional building materials. Use of glass, which can be coloured as desired, opens up largely un-investigated possibilities.

It is amusing that banks seek to please customers by offering a per-sonalized choice of colour in bank-cheques; it is surprising governments do not use a different colour for printing each separate denomination of paper currency. [8] It is wise that taxi-cabs in New York City are yellow, so that they can be easily distinguished in heavy streams of traffic; it is surprising that police officers on routine duty do not wear a distinctive colour so that they might be more easily seen in crowds of people. Perhaps life guards on public beaches must wear, from now on, a dis-tinctive *style* of bathing suit; the orange colour of their suits, which enabled them to be identified in the past, is no longer functional since many men and boys wear orange bathing suits. The rain-slickers worn by sailors and fishermen in storms at sea were originally made in bright yellow to provide high visibility. Later, these slickers were adopted by the public and their yellow colour, no longer a functional necessity, was retained as a convention. Finally, the convention of yellow rain-slickers was discarded and today these are made in a variety of colours.

8 In the United States, two-dollar bills were removed from circulation partly be-cause many people confused them with one-dollar bills; the problem might have been completely resolved by printing two-dollar bills in a different *colour* than one-dollar bills. In addition, the government seeks to prevent counterfeiting by use of a special paper on which currency is printed ... but counterfeiters bleach the ink from one-dollar bills and use the paper to print twenty-dollar bills. This particular type of counterfeiting could be eliminated if the paper used for one-dollar bills differed in *colour* from the paper used for twenty-dollar bills.

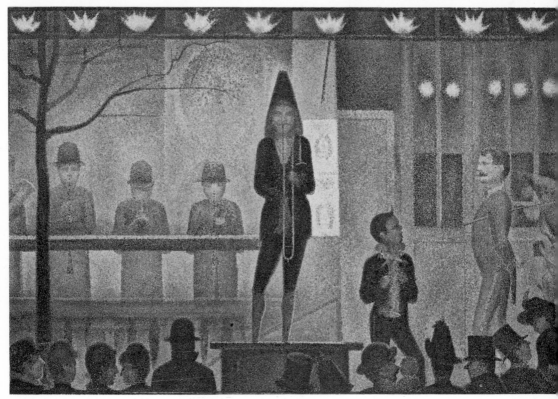

42. Georges Seurat. *La Parade*. Oil on canvas. 39 1/4 x 59″. Seurat's technique dividing colour into tiny particles was to some extent inspired by the scientifi theories of Chevreul and Rood. Photo courtesy of The Metropolitan Museum Art, Bequest of Stephen C. Clark, 1960.

Colour—and the use of colour—changes with a constantly changin context. No colour decision is ever final, but must be continually re examined. Colour imagination and colour sensibility can exist only as lon as colour thinking continues; when colour thinking stops, colour con vention begins.

Colour, nature, art and artist

As knowledge of colour relation advances, the restrictions imposed by tonality are relaxed. As a free society is envisaged in which each individual can exist in his own right without interfering with the rights of others, just so the restrictions imposed by tonality fall away and colours existing in their own individuality can be juxtaposed and (put) into just relationship with each other. This is the domain of colour proper and is exemplified in many examples of contemporary colour use.

Karl Knaths [9]

Colour has been used in a near endless number of ways in the art of the nineteenth and twentieth centuries alone. Colour has been manipulated for maximum contrast, and also for minimum contrast; it has been broken into the smallest possible dots and has also been used in the largest possible planes; some artists elect to use as broad a range of colours as possible, and others prefer a minimally narrow range. Colour has been, and is, used to create optical effects or plastic effects, decorative effects or psychological effects. There are a diversity of modes in which colour may be used. And an awareness of colour is of critical importance to the artist; colour is the raw material out of which paintings are made.

Colour awareness develops through experience, and through the deliberate attempt to cultivate colour-sensibility. Nature and Art provide dual sources of inspiration for the student in his colour studies. 'Nature', in its broadest sense, signifies the entire visual world, including both the world of growing things and the man-made world of rooms and cities and highways.

Few exercises train the eye better than does simple observation; the deliberate attempt to analyse minute differences in those colours which at first glance appear to be alike. A black cast-iron radiator differs in colour from a black leather chair, and may be lighter or darker, or more greyish or bluish or reddish or brownish. The black iron radiator and the black leather chair will both differ in colour from black velvet, a black book, or a black tree-trunk. A wooden floor, a wooden chair, a wooden T-square, a raincoat, may present four subtle variations on the colour usually called 'tan'. The colour of a green woollen sweater is never identical with the colour of a green tree or the colour of a lime. Sands differ in colour on different beaches; earth—the material from which the broad range of earth pigments is created—may be yellowish, or almost black, or brown, or reddish, or sometimes greenish. Two different types

9 Karl Knaths, 'Notes on Colour', in exhibition catalogue, *American Abstract Artists*, New York, 1946

of blue plastic may be similar but not exactly alike, in tone. A piece of fabric which has faded will differ in colour from another piece which has not faded. The purpose of visually analysing these minute colour differences is not, of course, for the purpose of later imitating the colour appearance of the objects on which these colours are found, but rather for the purpose of developing a sharp eye for all of the minute variations of colour which are possible. Whether such study of nature is attempted simply by looking at colours, or whether an attempt is made to match these colour observations in paint, matters little. What is important, however, is that the study of colour proceed through the eye, not the intellect; that it proceed through the observation of facts, not the learning of theories. Van Gogh sometimes studied colour by playing with pieces of coloured yarn, experimenting with the differing effects of various juxtapositions.

The study of colour in *art* has been praised for many centuries as the best road to insight into the use of colour. Delacroix, in his journal, wrote, 'Van Dyck uses more earthy colours than does Rubens, ochre, red, brown, black . . .' Delacroix's journal is invaluable for the many insights it gives into the artist's manner of studying colour, and includes numerous notes on colour effects he observed in nature and in art. Van Gogh, and also Matisse, sometimes made small pencil sketches in which they noted the colours which they planned to use in a composition. Again, whether the student writes down his observations, or makes sketches, is of less importance than the main point that he make a deliberate attempt to analyse the many ways in which colour has been used by artists. Small details should be noted, as well as those large overall habits of colour use which differentiate the work of one artist from that of others, and which determine the final effect created by the work of any given artist.

Much of the particular quality of a Van Gogh painting resides in his tendency to place red areas contiguous to green areas, bright blue next to orange or yellow, complementary colours in juxtaposition to each other.

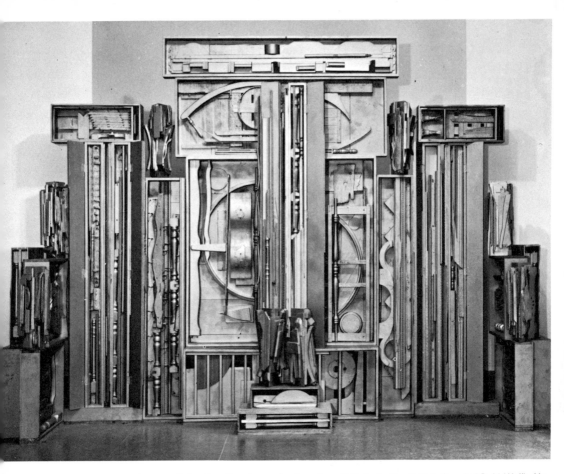

43. Louise Nevelson. *An American Tribute to the British People* (*Gold Wall*). Nevelson uses non-spectral colours, and has painted her wood constructions in monochromes of black, white, silver, or gold. Photo courtesy of The Tate Gallery.

44. John Ferren. *Duo*. 1966. 72 x 60″. Ferren, who recently lived for a year in Lebanon, is one of many artists who have been exposed to the art—and colours— of the eastern Mediterranean and North Africa. Among earlier contemporary artists who visited this area were Delacroix (who went to Morocco in 1832), Renoir (who travelled in Algeria in 1881), and Matisse (who visited Morocco in 1911). Photo courtesy of Rose Fried Gallery.

45. Paul Cézanne. *The Bather*. (c. 1885). Oil on canvas, 50 x 38 1/8″. Collection The Museum of Modern Art, New York. Lillie P. Bliss Collection. The blue tonality of much of Cézanne's mature work may perhaps, like Matisse's *The Red Studio*, be seen as a prototype for colour-field painting. Photo courtesy of The Museum of Modern Art, New York.

46. A 'minimal' palette. This palette will provide a far greater range of colour-mixing possibilities than any palette containing only a single red, a single yellow, a single blue; none-the-less, it is still severely limited. A major limitation of this palette for oil painting is that it provides only a very narrow range of bright purples.

A "MINIMAL" PALETTE

ALIZARINE CRIMSON: Use for mixing oranges and purples. When mixed with white, yields a bluish pink.

CADMIUM RED MEDIUM: Use for mixing oranges, but not for mixing bright purples. When mixed with white, yields a peach-toned pink.

LEMON YELLOW: A greenish, transparent yellow. Use for mixing oranges or greens.

CADMIUM YELLOW MEDIUM: A bright, opaque yellow.

THALO BLUE: Use for mixing greens, with lemon yellow.

ULTRAMARINE: Use for mixing purples, with alizarine.

WHITE

Matisse makes frequent use of combinations of pink, purple, and orange. Byzantine manuscripts often use 'off-key' versions of the primary colours: a purplish-red, a deep greenish-blue, and a yellow which is almost golden ochre or 'mustard yellow'.

Philip Guston often leaves an area of bare white canvas at one edge of his paintings; the effect of his dark and murky colours against this white area is quite visually different from the effect of the dark and murky, but transparent, colours in a Rothko painting.

A traditional concept of academic painting, probably derived from Japanese painting, is that one must view a painting from a distance which equals the length of its diagonal, in order to see the painting properly. Yet one must stand much closer than this to an Ad Reinhardt painting in order to perceive that the surface is not truly a field of unmodulated black, but consists of contiguous areas of near black with very little contrast between them. A series of drawings by Walter de Maria, consisting of single words pencilled very lightly in the centre of sheets of paper, also presents minimum colour contrast between object and ground.

Braque and Picasso, in their analytic cubist painting, confine themselves to colour schemes composed primarily of earth colours: greenish-browns, grey-browns, and ochres. Later, in many synthetic cubist still-lifes and interiors, Picasso often uses a colour 'scheme' in which he composes many colour areas, no two of which are the same colour.

The amount and disposition of colours plays as great a part in their net effect as does their absolute quality. When colour is broken up into tiny dots, as in the pointillist paintings of Seurat and Signac, it creates a different visual effect than when presented in large areas, as in colour-field painting or primary structure sculpture. Two colours which are placed adjacent to each other create a different visual effect than do those same two colours when separated by a black line (as in stained-glass windows), or by a white line (such as the grout of a mosaic).

The artist, unless he has chosen to work with coloured lights, must work with pigments, which do not always combine with each other in those

8. Pigments and the artist

I want a red to be sonorous, to sound like a bell; if it doesn't turn out that way, I add more reds and other colours until I get it.

Pierre Auguste Renoir[10]

My choice of colours does not rest on any scientific theory; it is based on observation, on feeling, on the very nature of each experience.

Henri Matisse[11]

modes which conventional colour theory would tend to suggest. Blue and yellow, when mixed, do indeed create green, but only in the limited sense that they do not create purple. Ultra-marine blue—a bright colour—and cadmium yellow medium—a bright colour—combine to form a dull olive colour with a greenish cast, and do not yield the bright colour which colour theory visualizes as the net result of union between two bright colours. A bright green can, however, be obtained by combination of thalo blue and lemon yellow. An empiric approach to the problem of pigment mixtures is highly to be recommended, nor—in fact—is there any real grounds for supposing that the theoretical constructions of colour theory would have a one-to-one relationship with the actualities of pigment mixture, or with the colour problems of the artist.

In particular, it should be remembered that colour theory visualizes all colours as constant in tinting power, which pigments are not. More important, colour theory visualizes all colours as interchangeable, and pigments emphatically are not. Bright purples are more easily obtained by use of purple pigments, and are almost impossible to obtain by mixture of oil-painting pigments. Whereas bright greens can be mixed, certain pigments such as cobalt green, cadmium green, or permanent green light *cannot* easily be matched by mixture. In fact, in view of the broad range of pigment colours available, better results are obtained if the concept of colour 'mixing' is abjured, and if the artist thinks in terms of colour *adjusting*, beginning with that pigment which is nearest to the colour he desires, and making slight adjustments to that pigment: Cobalt violet, adjusted by small amounts of alizarine, or ultra-marine, is more likely to yield a clear, bright purple of the type desired than is a combination of reds and blues. A somewhat similar condition prevails with browns: a large range of browns is available in the earth pigments, which, furthermore, are the most inexpensive of all pigments. There is no practical

10 Protter, *Painters on Painting*, p. 145

11 Alfred H. Barr, Jr., *Matisse, His Art and His Public*, New York, 1951, p. 121

value in expending time or energy to match a yellow ochre from the combination of more expensive pigments such as the cadmium reds and yellows with blues. Colour theory envisages a constant and ideal world, which contains as many reds as it contains yellows. Yet in the world of available pigments, there are more red pigments than there are yellow pigments. It need hardly be said, of course, that such colours as the metallic colours and the day-glo colours, which are not included in the postulations of traditional colour theory, cannot be obtained by mixture: the only way to create day-glo orange colour is with day-glo orange paint. Skill in the use of colour in painting best begins with a study of available pigment colours, and an awareness that many colours—contrary to theory—cannot be matched by pigment mixture. Observation of what various pigments actually do in mixture must in all cases take precedence over theoretical postulations about what two such colours should do in mixture. As in the case of ultramarine blue and cadmium yellow, standard colour theory provides approximate—but only approximate guidance.

Traditional colour theory relies too heavily, perhaps, on nineteenth-century physics. As has recently been noted, two coloured lights, when mixed in large, simple patches, may yield a certain colour. Yet these same two coloured lights, when mixed in small particles or in intricate patterns, may yield a totally different colour as an end product. This perhaps suggests that the differing coarseness of the pigment granules in various pigments may explain their behaviour in mixtures and also their varying tinting powers, in ways which are not yet understood.

In the event that it is desired to experiment with colour mixture in pigments, and if a broad range of colour effects is desired, it is not advisable to begin solely with red, yellow, and blue. Somewhat better results, and a broader range of colour mixing possibilities, may be obtained if a minimal palette is used which contains *two* reds, *two* yellows, and *two* blues.

Contemporary tendency to work with the juxtaposition of areas of extremely vivid colour has revived interest in after-image phenomena, and in the apparent penetration of an area of colour by the colour contiguous to it. Thin stripes of light blue and yellow, if the hues are carefully selected and the widths of the stripes controlled, can appear at a distance to be stripes of *green* and yellow. Related to this are the colour experiments of 'op' art which, however, are generally confined to those colours and configurations in which contrast is apparently high enough to strain visual capacity to integrate into a pattern on a single plane; an apparent 'jumping' or vibrating of the colours occurs.

Construct a grey scale. This may be done using paint, using found materials, or using swatches cut from photographic reproductions in magazines. Ten steps from black to white is a usual number for a grey scale, but other numbers of steps may be used; about 45 steps is said to be the maximum which can be visually distinguished by the student. Other types of colour scales—showing the intermediary tones between any two hues, or the range from full to low chromatic intensity, for instance—may also be constructed.

2 Maximal-contrast/minimal-contrast. Re-do the same composition twice, once using maximal contrast between adjacent colour areas, and once using minimal contrast between adjacent colour areas. This problem may be done in several ways: strong contrast between contiguous colour areas may be achieved by hue contrast (orange next to green, for instance), by value contrast (light next to dark), or by a combination of hue contrast and value contrast (a pale pink next to a dark olive green).

3 Make a composition using only greys, but do not use any achromatic greys (greys made only of black and white). Use greenish greys, reddish greys, yellow-ish greys, and other 'coloured' greys. Or collect a group of grey objects: Note how few of them will be achromatic grey.

4 Advancing and receding colours. Using coloured papers and collage technique on a two-dimensional surface, create the illusion of a depth of A) one mile to infinity, B) five to ten feet, C) one inch to perfectly flat. (*Problem suggested by Jean Cohen, Philadelphia College of Art*)

5 Field colour as a variable which creates apparent changes in the colours of figures. A) Take two 1 in. x 1 in. swatches of the same colour. Place each on a 6 in. x 8 in. field. Select field colours which will make the two identical swatches appear to differ in colour. B) Take two swatches of *differing* colour. Place each on a different colour field, the field colours selected to make these two differing swatches appear to be the same colour. (*Problem suggested by Frank Rivera, Michigan State University*)

6 Colour in art. Create a set of two to twelve colours which demonstrates the type of colour found in A) Art Nouveau, B) Rembrandt, C) Van Gogh, D) Matisse, E) Analytic cubism, F) 'Op' art, G) Impressionism, H) Egyptian wall painting, I) Pompeiian wall painting, J) Cézanne, K) Gauguin, L) Vuillard, M) Bonnard. Refer to original paintings or to reproductions. Where a particular type of colour juxtaposition, or a particular proportional balance among colours is an integral part of total colour quality, indicate this.

7 Using casein, paint a still-life in an Impressionist manner. Create the impressio
of local colour through use of sets of analagous colours: create green, for in
stance, through juxtaposition of small comma-shaped dots of yellow-greens
blue-greens, yellows, and blues. In shadows, use colour sets complementar
to the colours used in the object casting the shadow. (*Problem suggested b*
John Ferren, Queens College)

8 Texture and material affect colour. Render a blue cube, standing on a gree
table, against a red wall, under the following conditions: A) the cube is made o
blue metal. B) the cube is made of blue glass, C) the cube is covered wit.
blue satin, D) the cube is covered with blue fur.

9 Autumn leaves, when their colour is changing, provide a range of hues quit
different from either paint or paper. Create a series of compositions using leave
(or sections of leaves) in combination with paint or coloured paper. Use th
leaves as shape and as colour. (*Problem suggested by Hector Leonardi, Par*
sons School of Design)

10 Create a collage, using only day-glo, metallic materials (silver-foil, for in
stance), and opalescent materials (such as mother-of-pearl textures). Now pain
an exact copy of the collage, attempting as far as possible to duplicate th
original colours *without* using day-glo, metallic, or other special paints.

11 Take any three-dimensional object, which may be a shape you have mad
yourself, or may be a 'found' object—a box, a cup, a chair. 'Destroy' the actua
three-dimensional form of this object through use of colour: Paint its surfac
with colours and colour patterns which are sufficiently strong to take visual pre
ference over the 'real' form of the object.

12 Colour, never an independent entity in art, is part of a total work. Colour exist
in a context which involves not only colour relationships, but simultaneou
relationships of mass, plane, line, space, movement, rhythm, speed, size/pro
portion, shape, texture, tension/compression, weight, tone/value, and light
shadow. The artist's philosophy (all of his thinking), as well as his skill an
techniques, co-equally qualify the form in which this set of relationships is mad
manifest. In short, an artist uses colour in an individualized way, determined b
the work he is impelled to create. (*Statement by Raymond Hendler, The Schoo*
of Visual Arts)

Bibliography

The Journal of Eugene Delacroix (trans. Walter Pach, N.Y., 1948), *The Letters of Vincent Van Gogh* (ed. Mark Roskill, N.Y., 1963), and the writings of Emil Nolde are notable for their extensive notes on colour. Pissarro's views on colour may be found in his letters, some of which are collected in *Letters to Lucien.* Letters to the dealer Paul Durand-Rel and Henri Van de Velde outline Pissarro's colour theories, and his rejection of Seurat's divisionism These letters may be found·in *Impressionism and Post-Impressionism 1874-1904* (Linda Nochlin, ed., N. J., 1966). Miss Nochlin's book also contains Paul Signac's resumé of divisionist colour theory. The colour theories of the Neo-Impressionists are outlined in a letter from painter Georges Seurat to Maurice Beaubourg, reprinted in *From the Classicists to the Impressionists* (Elizabeth Gilmore Holt, ed, N.Y., 1966). Henri Matisse's views on colour may be found in his 'Notes of a Painter' (1908), reprinted in Alfred H. Barr, Jr., *Matisse, His Art and His Public* (N.Y., 1951). Wassily Kandinsky discusses colour in both *Concerning The Spiritual in Art* (N.Y., 1947), and *Point and Line to Plane* (trans. Hilla Rebay, N.Y., 1947).

Karl Knath's 'Notes on Colour' and Fernand Léger's 'Modern Architecture and Colour' (trans. George L. K. Morris) appeared in the 1946 exhibition catalogue of the *American Abstract Artists* group. Sculptor-critic Sidney Geist's 'Colour It Sculpture' appeared in *It Is* magazine. Amadee Ozenfant wrote a series of articles on colour which appeared in 1937 issues of the *Architectural Review.* Painter Billy Apple has speculated on the possibilities of laser pictures in 'Live Stills' (*Arts,* Feb. 1967).

From an earlier era, *The Notebooks of Leonardo da Vinci* (trans. Edward Mac-Curdy, N.Y., 1939) contain an extensive section on colour. Josef Alber's *Interaction of Color* is a contemporary classic. L. Moholy-Nagy's *Vision in Motion* and Gyorgy Kepes' *Language of Vision* both contain discussions of colour. Johannes Itten's *The Art of Color* also presents the Bauhaus approach.

The student will also find the following books useful:

Birren, Faber, *The Story of Colour from Ancient Mysticism to Modern Science* Conn., 1941

Chevreul, M E., *The Principles of Harmony and Contrast of Colours*, London 1854 New edition, N.Y., 1967

Davson, H., ed, *The Eye*, N.Y., 1962

Edwards, Edward A., and Duntley, S. Quimby, 'The Pigments and Color o Living Human Skin', *The American Journal of Anatomy*, 65:1-33 (1939)

Evans, Ralph M, *An Introduction to Color*, N.Y., 1948

Foss, Carl E., Nickerson, Dorothy, and Granville, Walter C., 'Analysis of th Ostwald Color System', *Journal of the Optical Society of America*, 34: 361-381 1944

Goethe, Johann Wolfgang von, *Theory of Colours*, trans. Charles Eastlake London, 1840

Gregory, R. L., *Eye and Brain: The Psychology of Seeing*, N.Y. ,1966

Helmholtz' Treatise on Physiological Optics, James P. C. Southall, ed., Th Optical Society of America, 1924

Huygens, Christian, *Treatise on Light*, Silvanus P. Thompson, trans., Chicago 1945

Massachusetts Institute of Technology, The Color Measurement Laboratory *Handbook of Colorimetry*, Cambridge, Mass., 1936

Newhall, Sidney M, Nickerson, Dorothy, and Judd, Dean B., 'Final Report of th O.S.A. Sub-committee on the Spacing of the Munsell Colors', *Journal of th Optical Society of America*, 33: 385-418, 1943

Parsons, Sir John Herbert, *An Introduction to the Study of Colour Vision*, Cam bridge, Eng., 1924

Polyak, Stephen L., *The Retina*, Chicago, 1941

Rood, Ogden N., *Student's Text-book of Colour*, 1881

Strong, John, *Concepts of Classical Optics*, San Francisco, 1958

Teevan, R. C., and Birney, R. C., eds., *Colour Vision*, N.Y. 1961

Wright, W. D., *Researches on Normal and Defective Colour Vision*, St. Loui Mo., 1947

The Measurement of Colour, London, 1944